Merry Christmas
Annie
Welcome to the
world

spectacles

spectacles

Samuele Mazza

CHRONICLE BOOKS
SAN FRANCISCO

First published in the United States
in 1996 by Chronicle Books.
Copyright © 1995 by Idea Books, Milano.
Translation copyright © 1996 by Joe McClinton.

Printed in Italy

Photographs by Giuliano Plorutti
Art Director Mario Piazza
Exhibition Services by W.E.A.
 (World Exhibition Assoc.)
Translation by Joe McClinton
Cover and text design by
Brenda Rae Eno at Blue Design

ISBN 0-8118-1367-3
Library of Congress Cataloging-in-Publication
Data available.

Distributed in Canada by Raincoast Books
8680 Cambie Street
Vancouver, B.C. V6P 6M9

10 9 8 7 6 5 4 3 2 1

Chronicle Books
275 Fifth Street
San Francisco, CA 94103

Further thanks to L.A. Eyeworks for the collaboration and the
loan of the works of the following artists:

Brian Adam
Vicky Ambery-Smith
Hilary Beane
Charles Elkaim
Bill Gale
Gal Gherardi & Barbara Mc Reynolds
Linda Hesh
Marcia Macdonald
Thomas Mann
Mary Beth Rozkewicz
Rhonda Saboff
Joyce Scott
Adam Shirley
David Spada
Emily Steffian
Deb Stoner
Vernon Theiss
Ellen Weiske

C O N T E N T S

Foreword

Samuele Mazza 9

Virtual eyes

Cristina Morozzi 13

Glasses for seeing

Marco Meneguzzo 21

Revolutions in sight

Luca Gafforio and Giulio Ceppi 28

Vegetable and Mineral 43

Seeing and Glimpsing 59

Looking Beyond 91

Looking Obliquely 123

Seeing and Seeing Beyond 151

Men and Other Animals 173

Index of Artists 188

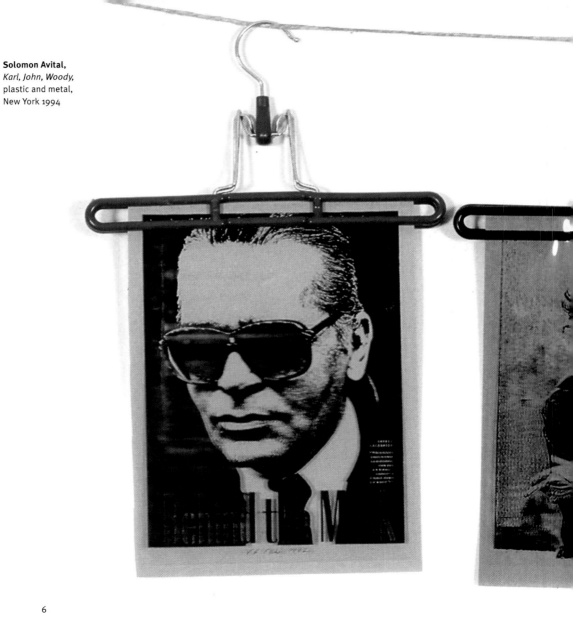

Solomon Avital,
Karl, John, Woody,
plastic and metal,
New York 1994

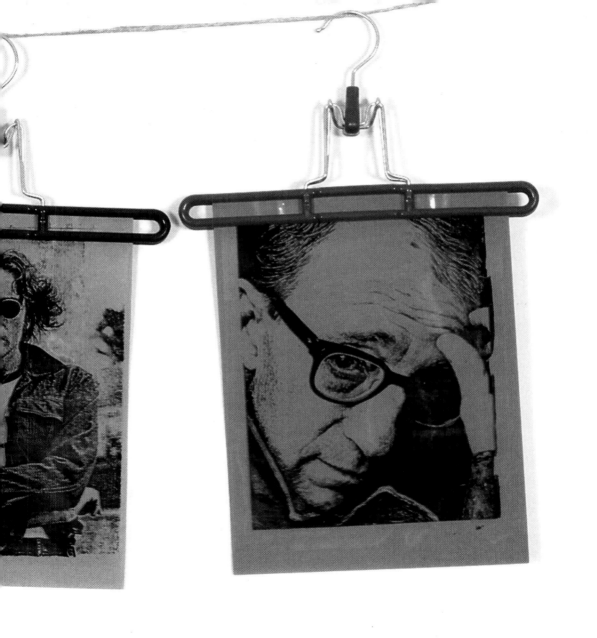

"Being a little blind is perhaps useful for a photographer because it may help his creativity."
-Oliviero Toscani

Foreword

Samuele Mazza

Spectacles is a volume dedicated entirely to eyes and eyewear. Following *Brahaus* and *Cinderella's Revenge*, it is the third in a series of books and exhibitions that takes its inspiration from fashion accessories—the latest installment in an ongoing creative and interdisciplinary exploration of the body. In *Brahaus*, we examined the feminine silhouette, and our focus on the breast and brassieres yielded a collection of playful and symbolically charged images. In *Cinderella's Revenge* the subject was the foot and its dynamics.

Giorgio Armani,
Cavour,
Metal,
Milan 1995

I would venture to define glasses—the third topic of my research—as expressionist. By that I mean not the art movement, but the fact that glasses are a metaphor for facial expression, an expression that glasses can change, letting the wearer choose a look that suits his mood. As Italian singer and songwriter Franco Battiato's lyrics say, "Some people put on dark glasses to heighten their charisma and mystery."

Yet glasses are not only a matter of metamorphosis, but also a necessary tool that creates a kind of dependence. Creative designs have lent both sunglasses and prescription glasses a myriad of stylistic connotations, as in Giorgio Armani's masterful reproduction of the type of spectacles worn by Count Cavour, the nineteenth-century Italian statesman; or Israeli artist Salomon Avital's Woody Allen–style horn-rims; or "cat glasses," movie-star wraparounds and Blues Brothers shades.

Women who wear glasses have an allure that the French call *le charme des types,* or the art of turning a flaw into an asset. Meanwhile, some men who wear glasses have been known to be faking defective vision, sporting exquisite-looking frames and false lenses in a bid for an irresistible air of culture and refinement, since, as everybody knows, prescription lenses seem to be synonymous with intelligence.

I have invested three years of my life in seeking outstanding examples of this object-subject. I hope this volume will be as well received as my previous works.

I want to thank everyone who worked on this project. Since there are so many of them, I have listed their names with the acknowledgments.

This volume is dedicated to all those who have donated their corneas; peace be with their souls.

Samuele Mazza,
*In uscita—in entrata
(Going out—Going in),*
Wood and metal,
Milan 1994

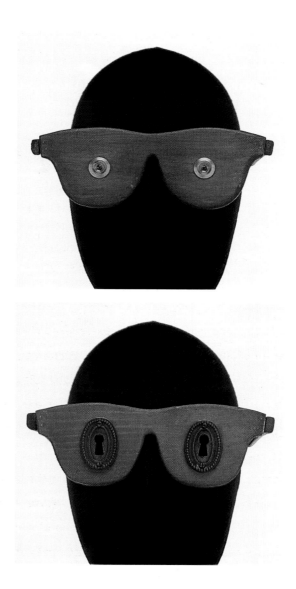

Virtual eyes

Cristina Morozzi

Glasses can be counted among today's many mythologies—perhaps among the most significant. That much is self-evident, even without recourse to Roland Barthes. The long history of eyewear is similar to the triumphal march of the foot soldier who becomes a conqueror. Glasses no longer play the role of attendant to the eye, as a crutch does for a game leg, or a hearing aid for a bad ear. Their status is one of replacement and dominance. In symbolic value, too, they no longer merely represent eyes but have supplanted them, masking the face.

Glasses draw all their power from being a mask. It is the power of seduction, playing with mystery and with the deception inherent in disguise, in eyes that see without being seen. They are not mere lenses, but screens and mirrors whose frames function as picture frames, elevating them from lowly instruments to works of art.

This aspect of being framed accounts for much of the appeal of glasses. These prostheses quickly take on a life of their own: their image replaces the eye.

In their role as masks, mirrors, picture frames, and so on, glasses have become mythical objects. They have been taken hostage by, and subjected to, the caprices of the fashion world, with its volatile comings and goings. The dazzling array of eyewear reflects the kaleidoscopic trends dictated by fashion. Yet on closer examination, perhaps, the roles are actually reversed — and it is glasses, as works of art, that dictate the ambiguous laws of fashion. The delicate relationship between lens and frame, or better yet, between mirror and mirror frame, has shaped the symbolism of celebrities who have allowed their glasses to become their defining image — celebrities who have become legends themselves, not coincidentally through their glasses. The part thus stands for the whole, and thousands of fans and followers wear the same glasses in an attempt to resemble their idols. This mania for identification has fostered a profound transfer of meaning. Glasses have come to represent cultural and spiritual values, evolving from masks into political and religious manifestos. A quintessential example is granny glasses. Worn by Gandhi, then by Allen Ginsberg, John Lennon, and

all those who wished to advertise their devotion to Eastern mysticism. Wire-rims became the eyeglasses of the engagé intellectual by association.

Since the times have made a necessity, rather than a ritual, out of fashion and style of dress—and since one's whole being is asserted through one's appearance—glasses are more and more a manifesto of a civilization that needs to declare its own ethnic, social, cultural and religious loyalties.

The history of glasses is more a social history than a history of style. Tell me what glasses you wear, and I'll tell you not only who you are, or who you'd like to be, but also where you stand on things. Other accessories can be deceptive; they can mislead even the expert on style and the mass media. But not glasses. Being mirrors, they always tell the truth—a multifaceted truth made up of eternal myths as well as passing fads. Fashions in glasses are irresistible; since glasses replace the eye, their allure is, above all, a matter of enchantment. Here is just a sampling from the vast repertory of legendary cult glasses from the past season: Speckled-plastic Persols, once favored by movie stars in the fifties; Webs, worn by test pilots in Seattle in the thirties but currently displacing the classic RayBans in the popular imagination; Black

Flys, a line of thirty retro styles, including an Elvis Presley model and the butterfly frames worn by Hollywood divas; and finally, the latest thing, the Catfish model, a new masklike style by Arnet worn by all latter-day Don Juans, including the model in the Martini ads. You only have to look around, from the metropolis to the countryside, to see that everybody is wearing glasses, whether they need them or not. Glasses can be phenomenally successful; they can come to stand for an entire era. Take the Svietka model. Created by Luca Gafforio in 1989 and manufactured by Moda Solaris, it followed in the wake of the success of the Russian "Raketa" watches. Intentionally downscale and available at market stalls for around ten dollars, Svietkas sold in record numbers—over fifty thousand pairs in two years' time. Although a strategic marketing decision took them out of production some time ago, their image has yet to fade. They were worn by a model on the front cover of a summer 1994 issue of the Italian weekly *Espresso* to hype a report on Ecstasy.

As devices, or more precisely prostheses, intended for mass production, glasses are quite legitimate objects of design. Indeed, by virtue of their complex symbology and intimate ties to vision—the aesthetic sense par excellence—glasses

Glasses in religion for
Red Rose Project,
M. Buosi and
L. Stramare.
Photo G. Favero

belong to a category of objects, perennially poised between art and design, that is especially favored by the new generation of designers. The further technology advances in solving the problem of the visual prosthesis with miniaturized lenses (contacts) that need no frames, the more designers focus on the silhouette. They have made the relationship between frames and specs, expressed in ever more original ways, into a vehicle for messages and a means of self-expression. The decorative approach of centuries past treated glasses as jewelry. Their uniqueness lay in the preciousness of their materials and the abundance of their decoration. Today the priority goes instead to line, as a structure for meaning. As they gradually lose their rich ornamentation, glasses grow richer in new implications. To use a linguistic metaphor, you could say that glasses constitute a new allegorical grammar. Each shape suggests a more or less overt allegory about vision. There is ample reason to indulge one's whims, as the designers of this exceptional collection of glasses have done. Using the most unexpected, unusual materials and exploiting every opportunity for cross-reference, they have created a tongue-in-cheek game of visual allegories and explored all the nuances of "ways of seeing."

It is not merely by chance that this collection is so rich in implications of every category from philosophical to sexual; since glasses carry meaning, they are an ideal vehicle for messages. But let us focus on the object itself rather than its meanings, leaving it to the reader to discover other possible messages that glasses, as deceptive masks, seem mischievously to enjoy camouflaging. The allure of the glasses we have assembled for you undoubtedly consists in the ambiguous interplay of allusions, in the references to seeing in all its subtle perversions, in taking away sight from the eye and replacing the eye with a mask that leads the reader into the realm of disguise and mystery. But also and above all, for those who consider them from the point of view of design, the mystique of glasses lies in their undisputed sex appeal. "The sexuality of the organ without a body," writes Mario Perniola (*Il sex appeal dell' inorganico* [Turin: Einaudi, 1994]), "derives precisely from its being perceived as a prosthesis endowed with sensation, an artificial device equipped with an independent perception all its own." Glasses are a full-fledged prosthesis and are conceived as such, but at the same time they possess an autonomous aesthetic that transcends mere function and becomes pure performance. Indeed, glasses possess all

the evocativeness of performance, including its erotic and perverse elements. Since their capacity to stimulate is often superior to that of the eye, they are becoming indispensable—not for seeing, but as a mimetic display. Nowadays, in the perennial game of seduction, we no longer refer to "glances that slay" with desire, but to "killer" glasses. Perhaps the unknown epigraphist was right when, in 1317, he wrote on the tomb of Salvino Armati in Florence, "Here lies Salvino Armati, the inventor of glasses. May God forgive him for his sins." Even if glasses have been around for hundreds of years, they look like the most modern of creatures, comparable to the cyborgs described by William Gibson in *Neuromancer,* the first novel of the cybernetic era. Glasses are bodies without organs yet able to express a sexuality that has no need of orgasms.

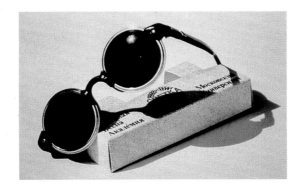

Glasses for Seeing

Marco Meneguzzo

To the artist, glasses are a metaphor for sight even more than they are a tool. When he confronts them as an object or as an image, he has no need to think primarily of how they should be designed or used. There are others who do that better and probably with results that will be more usable and pleasing than his—as is proved by this volume, overflowing with fantastic and extremely elaborate objects that are nonetheless still glasses. At this point, someone (just like the most pragmatic and prosaic of the three friends in *Three Men in a Boat*) might ask what on earth a collection of eyeglasses would offer, if not eyeglasses. Yet a certain habit of allegory, along with the symbolism inherent in any object that artists touch and manipulate, affords ample license for almost acrobatic exercises in style and criticism.

And so, glasses are not glasses.

We have said they are a metaphor for sight, and now we can add that they are the "modern" metaphor for sight—because the old, classical metaphor is quite different, and a good deal more tragic. In fact, classical antiquity, as well as all the non-Western paths of esoteric knowledge—or those only borrowed by the West, like alchemical practices—teach that what we commonly see is not a real view of the world as it is, but pure appearance, a phantom, a deceptive illusion, as the wise man is well aware. On the other hand, perception of the world as it really is comes only at a very high price, a price that only the initiated and those touched by the gods are willing or able to pay in order to rise above appearances and reach real substance. This price is that of being different, which in myth always takes the tragic form of isolation, both physical and psychological.

It was Cassandra's fame to be the prophetess of misfortune, and her destiny never to be believed; while Tiresias paid for the veneration of his people with blindness. So here is the tragic paradox: To see, one must be blind. Physical blindness may be a gift from the gods, not a curse; like any other difference—of the mad, of the artist—it is the sign, if not of divine favor, then at least of special attention from God, whether for good or for ill.

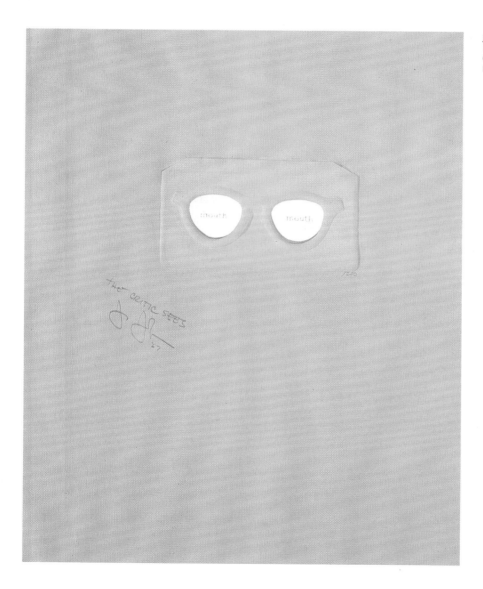

Jasper Jones,
The critic sees,
Canvas,
New York 1967.

So from now on, the near-sighted or astigmatic can feel much better able to prophesy than run-of-the-mill "twenty-twenties."

Of course things are not really so, because modernity—the kind that dates at least from the Renaissance—has diluted myth with the water not so much of reason as (even worse) of being *reasonable,* which will not tolerate excursions beyond the rules of good sense. A modern Oedipus would most likely not blind himself in expiation, but go into analysis instead; just as nobody would care to trade their own sight for the gift of prophesy, or wisdom. Tragedy (whether as a metaphor or as a genre) no longer exists; it has been replaced by the more reasonable form of comedy, or at most by drama. And where do glasses come into all this?

In this scenario, glasses seem like the instruments of modern, bourgeois reasonableness, as though sight were a mechanical action that subscribes to common, identifiable standards. (There are still those who think El Greco's elongated figures are the products of a visual impairment, and not of sublime Spanish Mannerism.) Seeing, or not seeing, has ceased to be a metaphor for wisdom and has become a matter for the optician.

To tell the truth, at least at the beginning of their modern history, glasses had still partly retained a trace of symbolism, if only because they served to identify not the wise man, but at least the cultivated man, the intellectual, somebody who had something to do with reading. But at the same time, in the history of art—particularly Flemish art, which was more attentive to the anecdotal and to everyday life than was the art of Renaissance Italy—glasses were often a sign of unappealing people; merchants, notaries, lawyers, and bankers, in short, a catalog of the establishment of the age, were sketched with the kind of pseudo-scientific crudeness that can never transform an eager old codger into an attractive man.

So do artists have an aversion to glasses? Surely not as an object or an instrument. On the contrary, in this capacity they are stimulating, as witnessed by the many examples created by a large number of international artists for this collection. But as a symbol, yes indeed: For the artist, glasses symbolize something far greater than their physiological function. They are the reminder of a loss, the loss of myth.

They say Nero used to look through a natural lens made of emerald. Was he compensating for myopia, or trying to see the world transfigured? Between the first

hypothesis and the second lies the collapse of mythic reality and the assumption that glasses must be functional, that despite themselves they must now play the rather uncomfortable role of reducing vision to mere sight. The vision of wisdom vanishes when everything is reduced to the visible standards of tangible, palpable objects; and glasses are the tool of this diabolical materialism.

Looking at it this way, we can understand why the artist usually holds no excess sympathy for an instrument that defines, and thus limits, our daily horizons. It is no accident that, unlike the designers, almost all the artists invited to join this collection have, in a certain sense, violated glasses as an object by rejecting their functionality in order to return the issue to the metaphoric, symbolic function of seeing. The designers, for their part, have created eyeglasses with shapes and implications infinitely more captivating than those conceived by the artists. The designers have exalted the decorative and the more-than-decorative function of the object, and risen to the highest peaks of cultural cross-reference; while the artists instead have tried to make vision visible, to return the focus to the problem of the current metaphor of seeing. The fact is that it is almost impossible to imagine glasses

for the "eyes" often painted on Buddhist stupas, or for the apotropaic eyes on the prows of many a Mediterranean fishing boat—or in other words, for eyes that are the symbol of transcendence, of seeing beyond. This says a lot about how eyeglasses belong to the reasonable everyday so hated by artists.

All the glasses by artists interfere with seeing. They force the wearer to reflect, throwing the gaze back at the gazer; at most, they permit us only to look at the world through bizarre shapes that transform the scene, blocking all familiar horizons and thus denying all tranquility. In the same way, which is almost a corollary of what we have just said, the artists' glasses, unlike the designers', are not declarations of loyalty to a group or demonstrations of social intelligence. They are not signals launched outward, but intimate instruments, attempts at achieving a new prophetic blindness.

Revolutions in Sight

Luca Gafforio and Giulio Ceppi

THE FIRST REVOLUTION

Eyeglasses acquired an identity as objects with a precise typology in the fourteenth century. In the thirteenth century, Roger Bacon wrote in his *Opus Majus* about magnifying lenses that could correct sight, and at the end of that century there is clear evidence that the optical technology (biconvex lenses) was available to correct far-sightedness. (The nearsighted would have to wait until the second half of the fifteenth century for concave lenses.) Glasses took on a permanent material definition, when someone thought of joining two corrective lenses together by means of a support structure, the frame. The first iconographic evidence of this dates from 1352.

The history of eyeglasses thus becomes the story of the relationship between lenses and their support, the history of an object made of two materials.

The first need served by glasses was substantially technical. Their primary

function was to make it possible to see better and farther, significantly increasing the productivity of scribes and artisans and, after the invention of printing around 1450, making it easier to read small type. Second, seeing better should be comfortable; in other words, glasses should stay put on the nose without requiring use of the hands.

Over time, the lens-frame dichotomy would be redefined in a new, complex, articulated assembly. The lenses would have the duty of correcting vision and (later) protecting the eyes, while the frame would assist this function as directly as possible.

From the very start, the iconography of glasses shows us glasses firmly perched on the nose of people bending over to write or read. In all probability it's a false image, because in fact the first problem that eyeglass makers had to confront was precisely how to keep them on the face. Their solutions were not the least bit satisfactory for centuries—so much so that users were forced to hold up their glasses with one hand. Later the encumbrance presented by glasses, and the consequent need to fold them and put them away, for they were still extremely rare and fragile objects, provided another area for craftsmen to apply their ingenuity. These two issues are actually tied together in a two-sided problem. Initially, in fact, the craftsman/optician

Glasses made form burnished steel to treat strabismus

had to select between two different frame structures: either jointed, allowing the glasses to be folded away after use, or in an arc, in a single piece with enough flexibility to allow it to grip the nose gently.

It is a peculiarity of glasses that they often have to cope with double problems. Another typical one is the relation between weight and size.

Quite apart from the requisite sophisticated handling of materials so they could measure up to the stresses of use, opting for

one aspect meant accepting deficiencies in the other. Although there is no clear proof, it seems that in the sixteenth century a pair of glasses with a "spring" frame was produced—the precursor of the nineteenth-century pince-nez.

Starting with the first jointed frames, frame design next moved to arc-shaped and five-bladed arc frames (in which the bridge was lightened by cutting parallel eyelets into it; it was more elastic, but also more fragile). Next came a system using laces, imported by sixteenth-century Catholic missionaries from the Far East, where it long remained in use. This was followed by elaborate retaining systems that could be worked into late seventeenth-century wigs (the so-called "suspended glasses," which had already been tried before, with metal hoops around the wearer's head).

In essence, it was only in the mid-eighteenth century (probably in 1750, thanks to an English optician named Scarlett) that people finally realized rigid arms worked better than purely elastic systems. But before we find longer arms, we have to wait for the end of the century, and especially for wigs to go out of style. These longer arms, curved to fit around the temples and reach around to the back of the

neck, made the glasses even more awkward when they were taken off, so people invented systems to fold or shorten the arms before the glasses were put away.

In the nineteenth century, people finally discovered ears, and earpieces were invented. Yet by one of the many odd vagaries in the history of glasses, this system was temporarily thrust aside by the pince-nez, which in its half-century of popularity carried technical refinement to new heights (this of course was the age of mechanistic positivism) with admirable and unequaled steel-wire micro-constructions and perfectly elastic bridges of piano-wire steel. The pince-nez reigned supreme; by mid-century models appeared that could be folded up by sliding the lenses over one another, making them compact while also storing up tension in the piano-wire bridge, which then relaxed during use. Here at last elasticity and foldability were combined.

It was advanced steelworking technology that made this possible. And thus glasses demonstrated their modernity as a place for experimentation with new materials and technologies.

From the very start, the frame had been made of many materials: wood,

horn, tortoiseshell, and whalebone; iron, copper, brass, silver, gold, nickel silver, and steel; and even the celluloid of 1879, ancestor of today's plastics.

Particularly interesting was the use of whalebone, a strong material with excellent elasticity (and thus comfort), one of the most widely used materials in the history of eyeglass making. From the sixteenth to the eighteenth centuries, the Germans made whalebone arc glasses on a semi-industrial scale, using raw materials obtained from the whaling industry of the North Sea. The results were exported all over Europe.

Finally, we cannot discuss the lens-frame relationship without mentioning Waldstein glasses. This line of models, produced around 1830 by two Austrian opticians, Voigtländer and Waldstein, had a front section made entirely of a single piece of optical glass (a "mask," as we would say today). There was no need to join the two lenses by a frame across the nose, and thus the shape of the glasses could be created absolutely at will by cutting the glass. Slender silver or gold earpieces were hinged directly to the edges of these "invisible" glasses, yielding stunning objects that were both absolutely beautiful and absolutely modern.

Riccardo Misesti
"8,"
Sanded glass,
Firenze 1994.

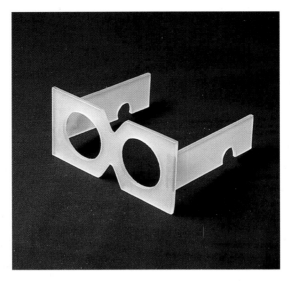

Anita Citron,
Parabrezza,
Steel and Plexiglas,
Como 1993.

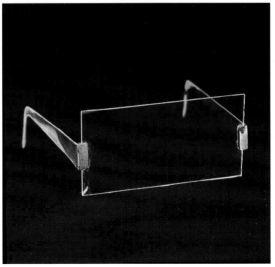

The Second Revolution

In the seventeenth century, corrective lenses also became protective—tinted on the surface by various pigmentation techniques, or ground from colored glass or quartz. From here on, we find corrective and protective lenses in conjunction, and doubled protective lenses where two lenses of the same or different colors were put together to intensify their darkness. The transition is particularly important. Set free from the reading room and the study, glasses went outdoors. From an instrument tied to the specific needs of doing something, glasses moved out into the total dimension of seeing. No longer a mere working tool, they became an integral extension that could be used any time, anywhere; no longer an indoor object, but a showy and public one.

Examples of this trend are the Goldoni, a Venetian model from the early eighteenth century made of horn with brilliant green lenses and silk sunshades at the side, or the Richardson, a splendid model from the early nineteenth century in which fixed corrective lenses were hinged to adjustable sun lenses.

Richardson glasses had an unquestionable fascination. In vogue throughout the nineteenth century, they came in a vast number of different designs and materials.

This revolution in use would gain in importance as the twentieth century brought new experiences and new developments: train glasses, the apotheosis of the technological pince-nez with a shaped metal "anti-soot" mesh; or goggles for aviators, automobile drivers, and motorcyclists (smoked lenses) mounted in metal-and-soft-rubber frames, closely fitted to the face and held in place by various elastic arrangements.

The science of optics (the chief reference point for glasses) and innovative technologies from the nineteenth century onward joined forces with a growing awareness of glasses as part of one's clothing to yield a quantity of astonishing objects, from short telescopes concealed in common objects (a veritable super-eyeglass for public voyeurism) to frames hidden in fans or sticks, monocles on a ribbon, and more and more daring experiments that questioned the very meaning of "glasses."

In some quarters these fashion objects utterly replaced the use of conventional eyeglasses, if only for a limited time.

In the first part of their several centuries of history, glasses found a

technical and functional justification that allowed them to define their own basic identity. In our own century, particularly since World War II, they have rapidly metamorphosed into an item of merchandise. An outstanding contribution in this regard came from plastics, from the first experiments with celluloid in 1879 (only seven years after the material was invented) to the use of Galalith and bakelite from 1900 to the 1940s, to the elimination of all formal limitations with innovative plastics and the new technologies of the 1950s and 1960s. Now fully set in terms of technique, technology, and materials, glasses became an extremely lively actor in the growing consumer culture.

The early 1950s saw the birth of two objects destined for immense success, particularly in the youth market that was then just beginning to develop: the first long-playing vinyl records and the RayBan Wayfarer frame designed by Ray Stegeman. Nearly forty years later, the Wayfarer's semantic content is intact, even as compact disc technology has rendered the LP obsolete.

The 1960s and pop culture gave a tremendous new impetus to glasses, which were often treated as gadgets. New lifestyles and new languages erupted into a

market of increasingly involved consumers, and the new game in glasses became saying yes to everything, and to its opposite, too. In 1968, when glasses by Dior used a new and particularly suitable material, Optil, by the Austrian designer Anger, high fashion finally took notice of these objects and quickly appropriated them on a massive scale. Within a few seasons, designers like Cardin and Courrèges ventured into the creation of new eyeglasses which were ever so "fashion show."

Although Dior's model is considered the founding example of fashion glasses, we must not forget that in 1940 Marcel Rochas designed and produced his own plastic flower glasses, sold along with other exclusive accessories at his Paris atelier.

The time was now ripe for the third revolution in eyeglasses: from the house-bound aspect of helping to do something, through the way station of public seeing, we came to the contemporaneity of one's look, of being seen, which means fully accepting the rules of fashion. In this sense, the history of glasses enters a new chapter in the 1980s, with the thoroughly Italian encounter between industry and the designers. On one hand we find the world's most vigorous industry for this sector, with an obvious aptitude for the product; on the other is the world's strongest fashion

Sunglasses, 1938.

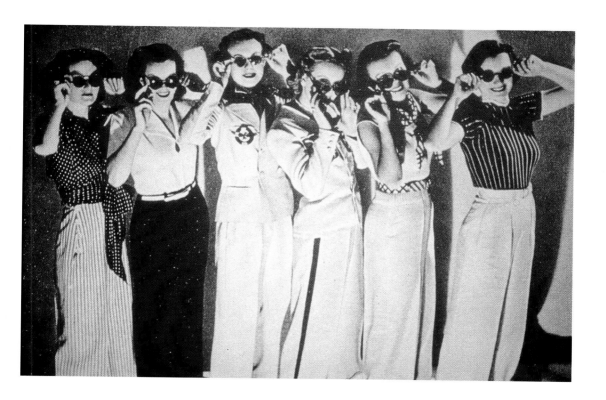

system, immensely skillful at seducing the consumer. And in between, eyeglasses: a piece of clothing and a sensitive weather vane for popular interest.

THE THIRD REVOLUTION

Nowadays the quality of an eyeglass design lies in its alertness to a perpetually changing market in which a merchandise-consuming culture is perfectly primed for the characteristics of glasses as an accessory: objects with a well-established image and fixed production techniques, but nonetheless endowed with enormous expressive force.

These qualities have made glasses extremely responsive to the market, and while this opens up obvious opportunities, it still offers no decisive competitive advantages. As soon as new semantic areas of success are discovered, imitators waste no time saturating the market with clones of the original products.

Some of the highest-profile makers have responded by continuously seeking technical solutions which, though traditional, are so highly refined that imitators find them inaccessible or uneconomical. (One example is the shift from injection-molded

plastic to metal, or in any case to complex techniques.) In this regard the relationship between the designer signature and the rest of the industry has been a milestone.

Merely displaying a logo (a sign of added value that is immaterial, yet so concrete) quickly and unequivocally sets off designer products against the rest.

And thus a careful commercial strategy, based on making the best use of fashion trademarks, has allowed some producers who moved especially quickly in this direction to gain enormous competitive and economic advantages in the past decade.

After the first period of stylish superficiality, with designer glasses coming perilously close to designer floor tiles, choices available to the consumer have established their serious credentials, and industry in this sector has learned much from fashion.

So it was that styling, and the synergism between industry and style, technology and seduction, have become all-conquering characteristics.

Glasses are sold not so much for their useful value (except perhaps as an excuse to buy them in the first place), as for their ability to interpret, or even to anticipate or provoke new languages of consumption.

VEG
ETABLE

Still life . . . with glasses. An ironic and perverse game of allusions and illusions.

AND

Fruit and vegetables as faces that look without eyes. Blindness as prevention.

Glasses, a metaphor of sight, to animate the inanimate.

MINERAL

**Oliviero Toscani and
Carlo Spoldi,**
Still life,
Milan 1994.

Giovanni Gastel,
Still life,
Polaroid 20X25 cm.,
Milan 1994

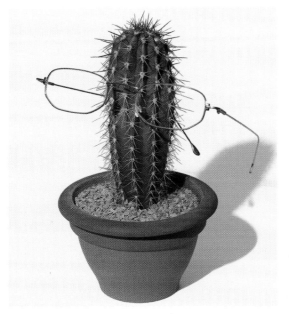

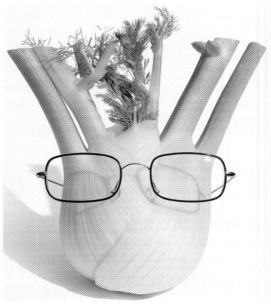

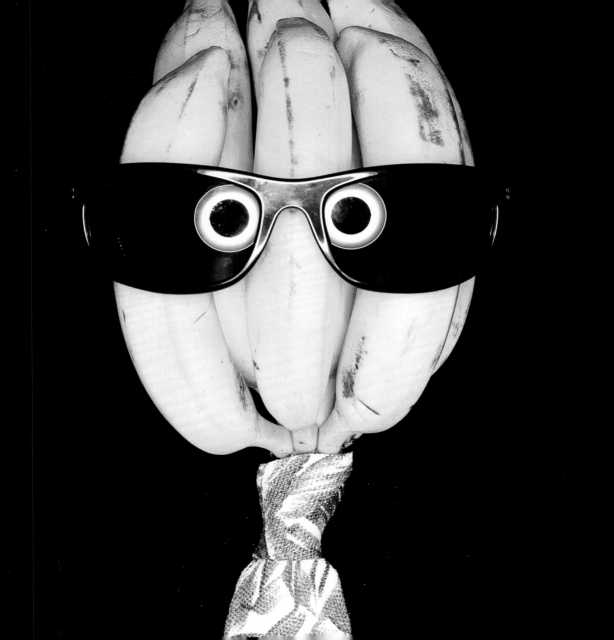

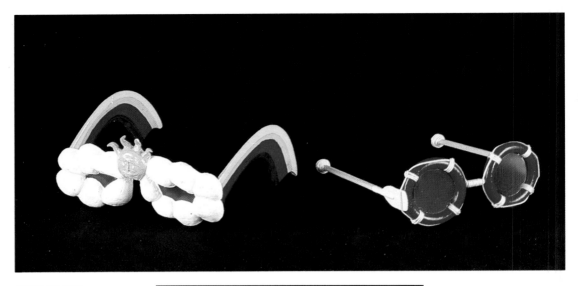

Adriano Giannini,
*Occhiali da sole
(Sun glasses),*
plasticine,
Florence 1995.

Ciro Romano,
*Occhiali da mare
(Sea glasses),*
mixed materials,
Florence 1995.

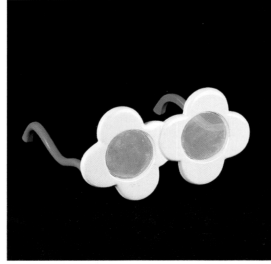

Claudia Landi,
*Visione rosea
(Rose-colored glasses),*
Wood and plastic,
Florence 1995.

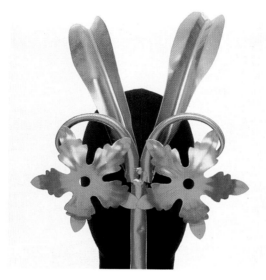

Monica Leoncini,
*Mimetici
(Camouflaged),*
metal,
Florence 1994.

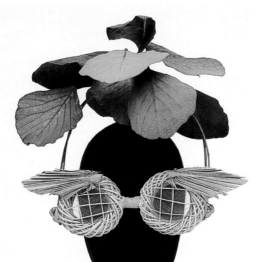

Paulyr Buehler,
*Eco-occhiali 100% nature
(Eco-glasses, 100% natural)*
mixed materials,
Lucca 1994.

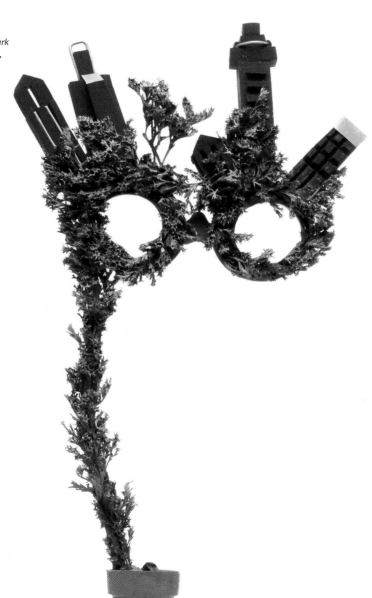

Glorimar Santiago,
Sguardo su Central Park
(View of Central Park),
mixed materials,
Puerto Rico 1993.

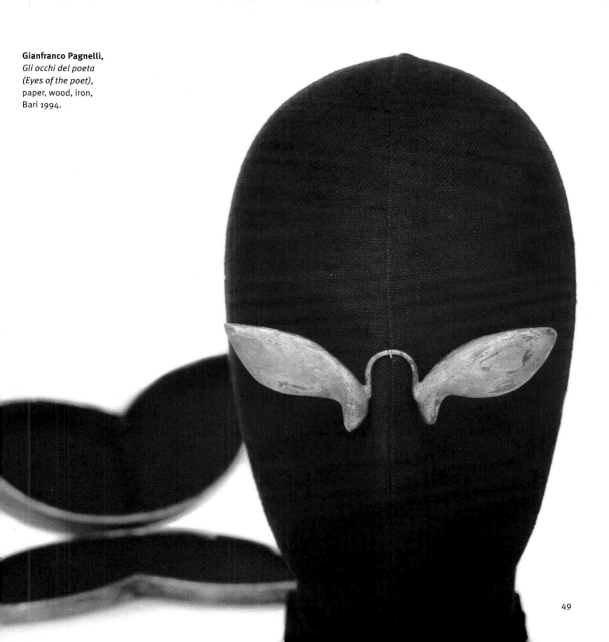

Gianfranco Pagnelli,
Gli occhi del poeta
(Eyes of the poet),
paper, wood, iron,
Bari 1994.

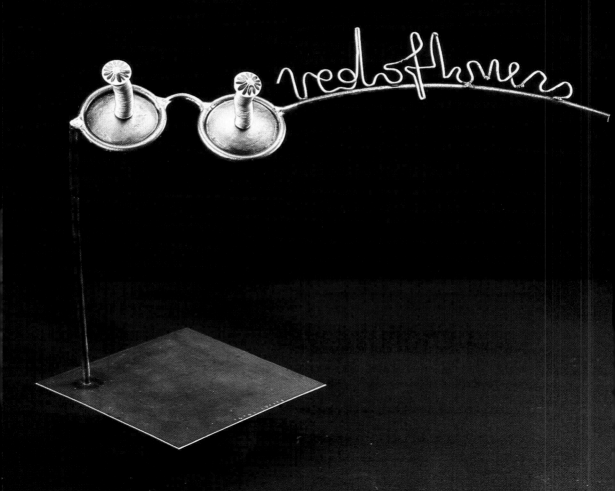

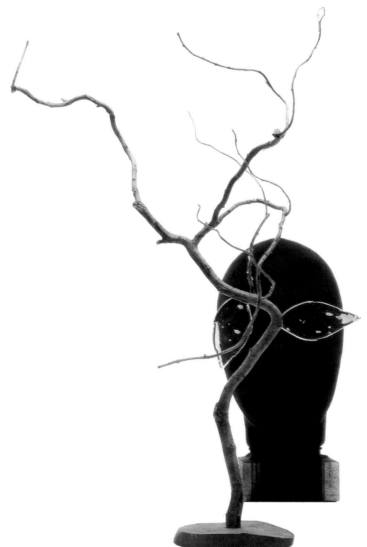

Elena Busisi,
Vedo Flowers
(I see flowers),
iron and porcelain,
Milan 1994.

Michael Celentano,
Sun glasses,
wood and glass,
New York 1994.

Thomas Mann,
Untitled,
mixed materials,
USA 1987.

Bettina Werner,
Ne te quaesi veris extra,
wood and coarse salt,
New York 1994.

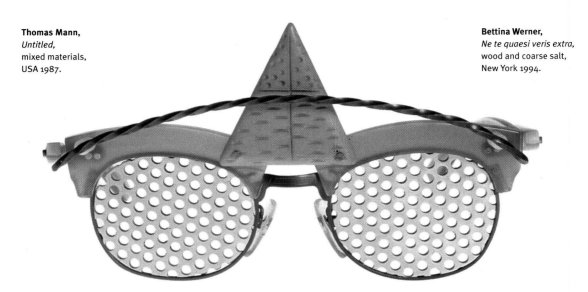

Thomas Mann,
Untitled,
metal and plastic,
USA 1987.

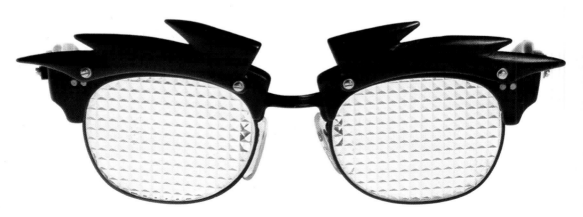

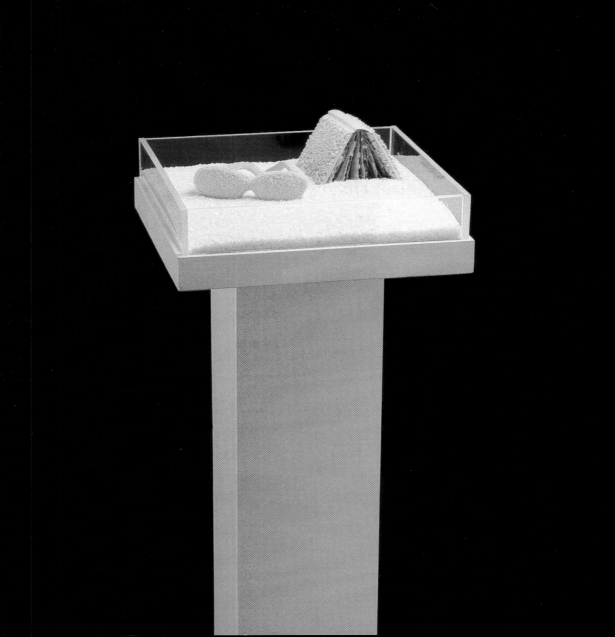

Maria Gloria Bianchi,
Peccato visuale
(Visual Sin),
ceramic,
Florence 1994.

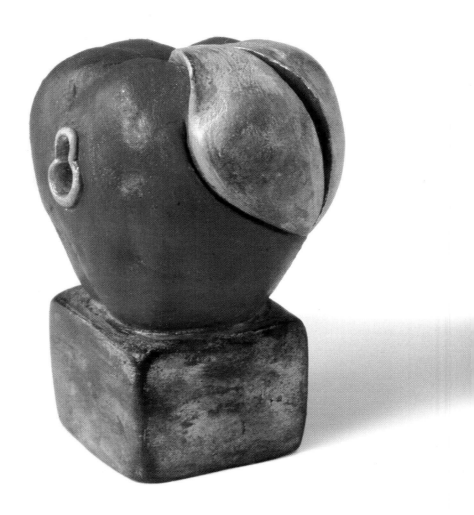

Brian Adam,
Coconut roughs,
woods and mixed materials,
Australia 1989.

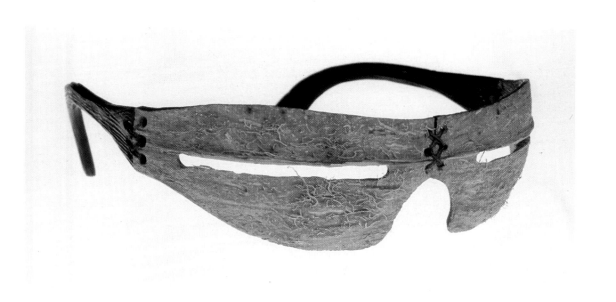

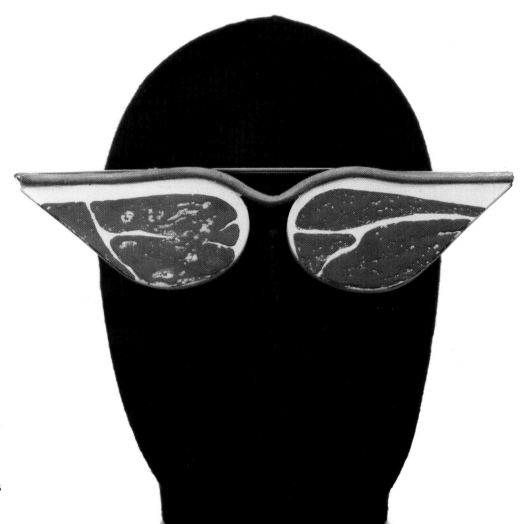

Oliver Moroni,
Occhi foderati di prosciutto
(No ham in sight),
plastic and metal,
Arezzo 1994.

Claudia Trevissoi,
Glasses,
glass,
London 1994.

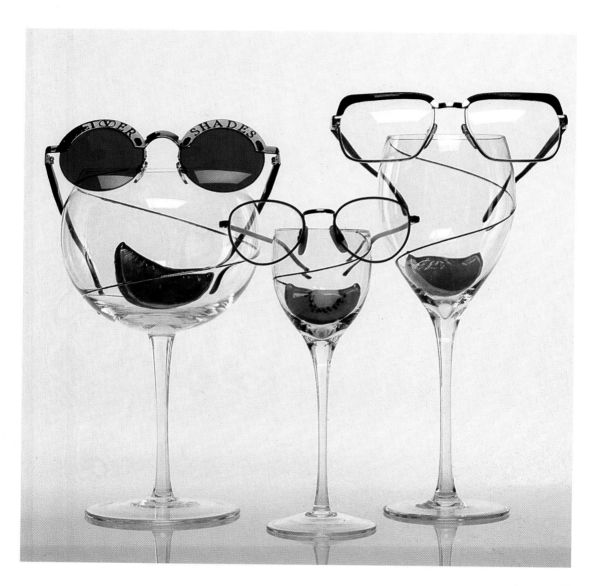

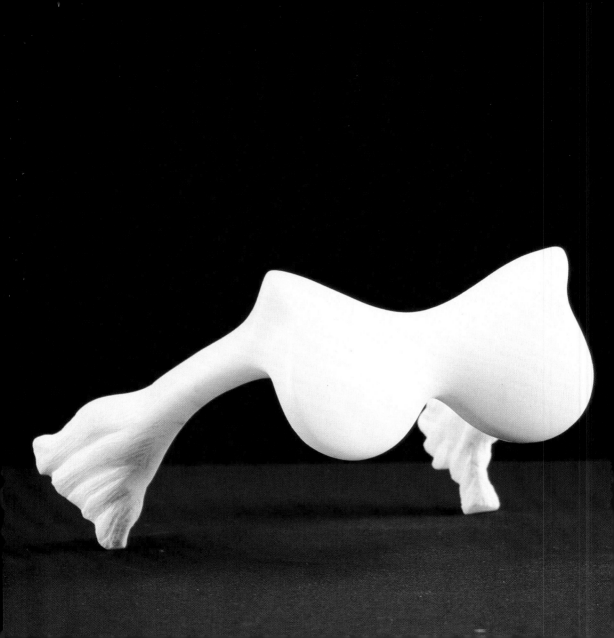

SEEING

Glasses as tricks, to mask in order to conceal or to camouflage. Seeing without being seen.

AND

Understanding without ostentation. Blind glasses for looking inwards.

GLIMPSING

Glasses: a mirror to reflect the true self.

Preceding page:
Luciano Massari,
Oculi in coelum,
marble,
Carrara 1994.

Fried Rosenstock,
Specchi delle mie brame . . .
(Mirror, mirror on the wall . . .),
wood and glass,
Florence 1994.

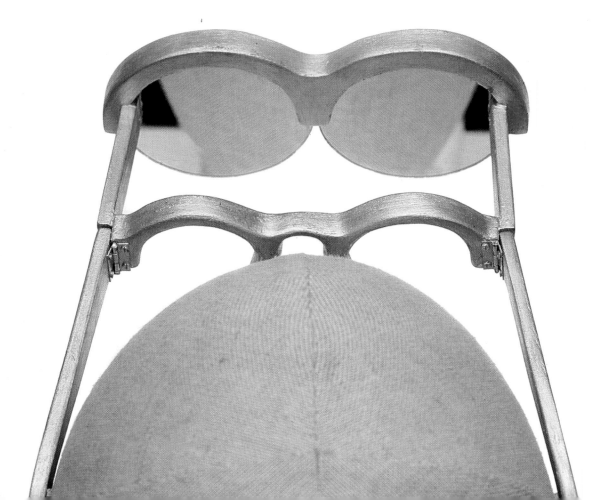

Chiara Dynys,
*Autocritica
(Self-criticism),*
metal and glass,
Turin 1995.

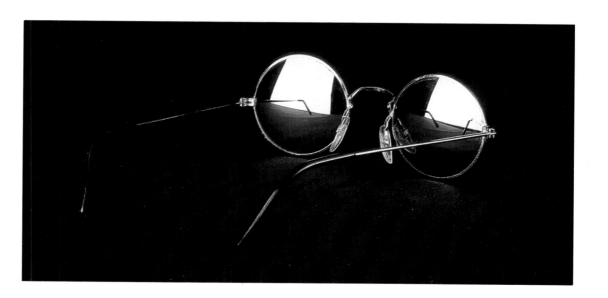

Nicola Salvatore,
Occhi a palla
(Bug-eyes),
metal,
Como 1995.

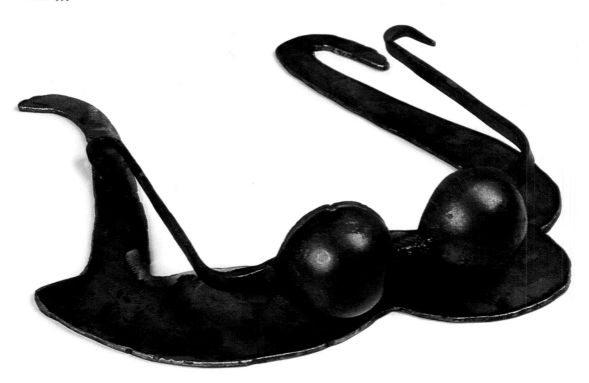

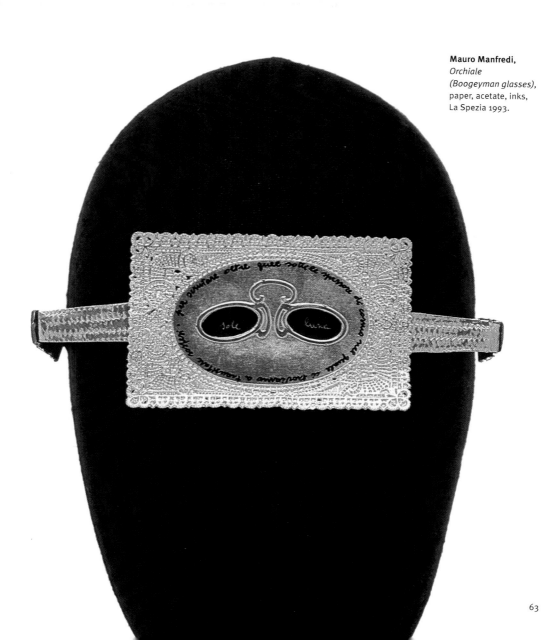

Mauro Manfredi,
Orchiale
(Boogeyman glasses),
paper, acetate, inks,
La Spezia 1993.

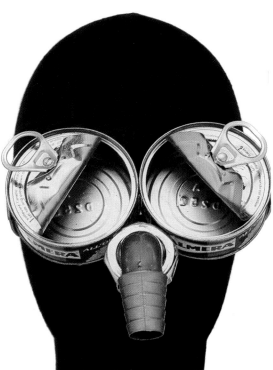

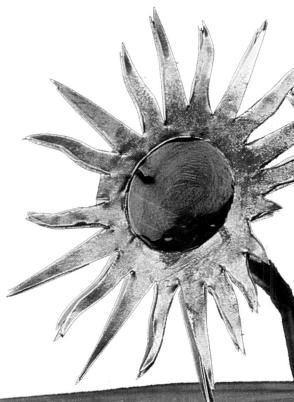

Maurizio Cosua,
*Senza titolo
(Untitled),*
copper and brass,
Venice 1994.

Fabio Conte,
*Sigillaocchi
(Sight sealer),*
metal,
Saronno 1993.

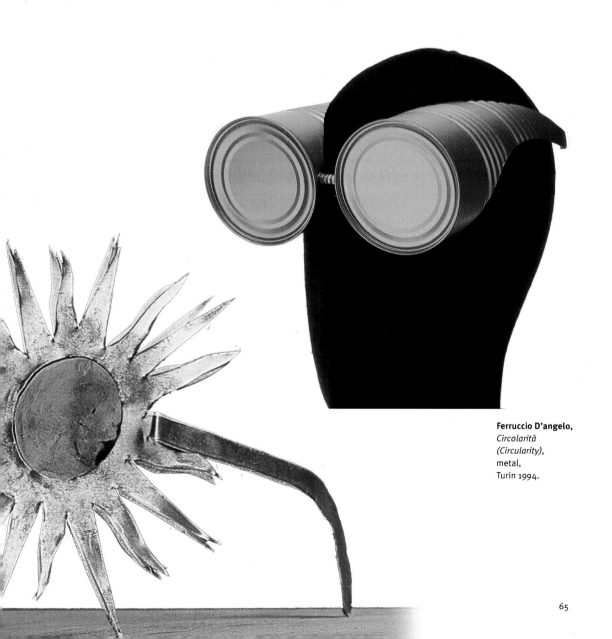

Ferruccio D'angelo,
*Circolarità
(Circularity),*
metal,
Turin 1994.

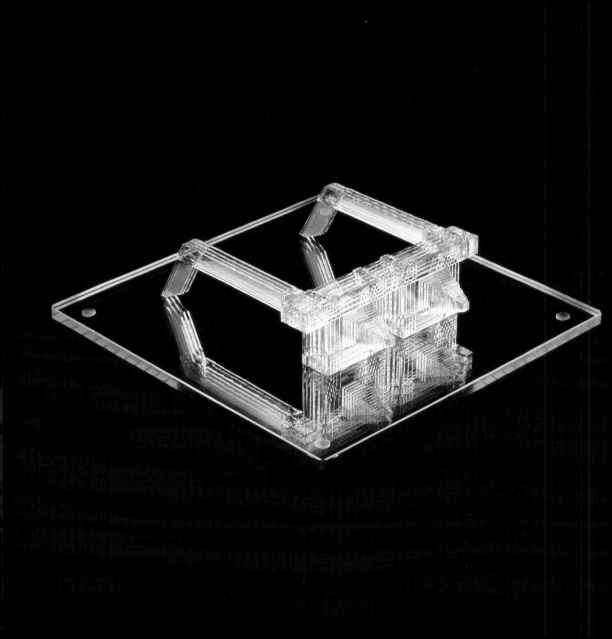

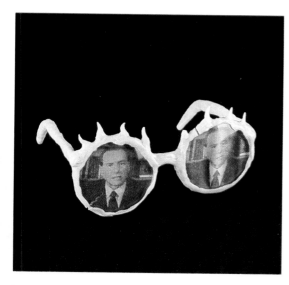

Alfonso Siracusa,
*Avvistamento
(Sightings),*
mixed materials,
Agrigento 1995.

Lorenzo Pezzatini,
*Berluscopio
(Berlusconiscope),*
friendly plastic and glass,
Florence 1994.

Izumi Ōki,
*Sguardo penetrante
(Penetrating gaze),*
glass,
Milan 1995.

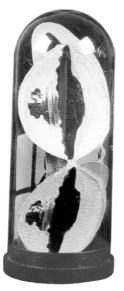

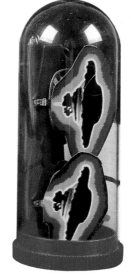

Andres Salas Acosta,
Magnetismo
(Magnetism),
stainless steel and leather,
San Juan, Puerto Rico 1994.

Paulina Humeres,
Occhiali
(Eyeglasses),
mixed materials,
Rome 1994.

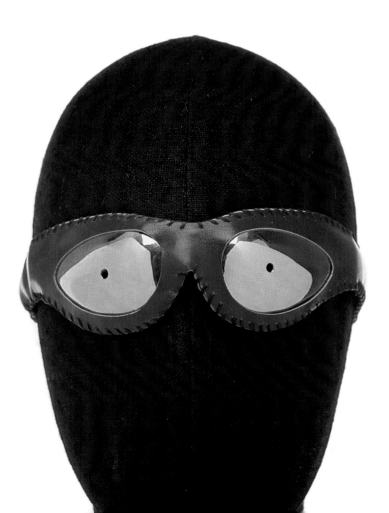

Luigi Billi,
*Biondo occhi azzurri
(Blond, blue-eyed),*
plastic,
Rome 1994.

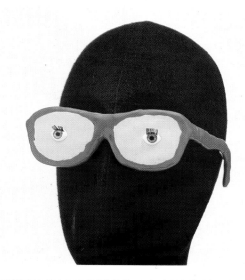

un dono

Simon Chalmers,
Woooo glasses,
raffia and bone,
London 1993.

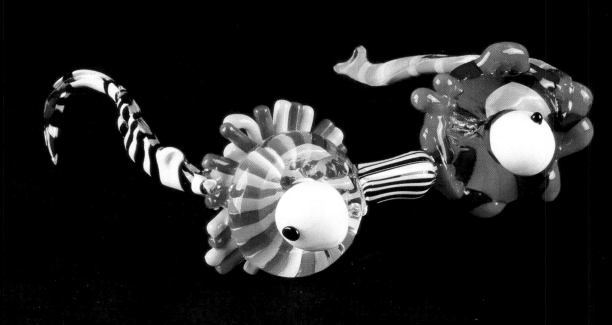

Maria Grazia Rosin,
*Strabicchio
(Cross-eyed),*
glass paste,
Venice 1995.

Nathan McNair,
*Liquidi corporei
(Body fluids),*
Plexiglas, glasses, condom,
Los Angeles 1994.

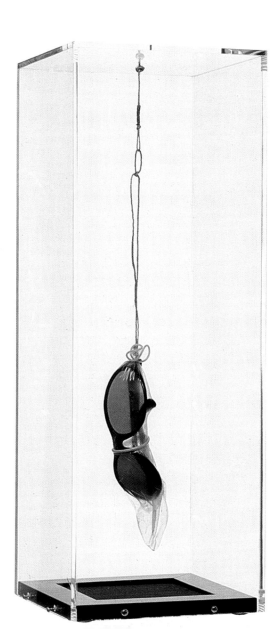

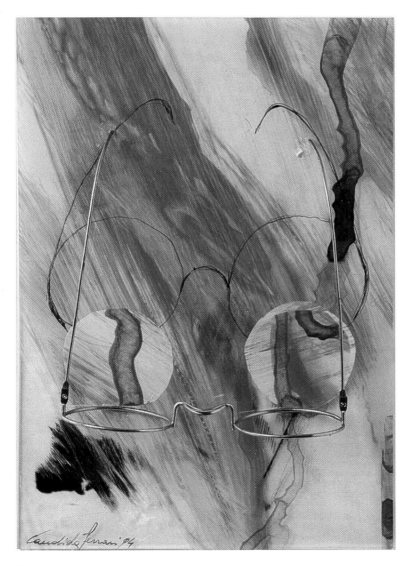

Candida Ferrari
Colpo d'occhio
(Quick Glance),
Plexiglas and mixed materials;
Parma 1994.

Maurizio Ruzzi,
Il bugiardo di Collodi
(Geppetto's lying boy),
wood and iron,
Pescara 1994,

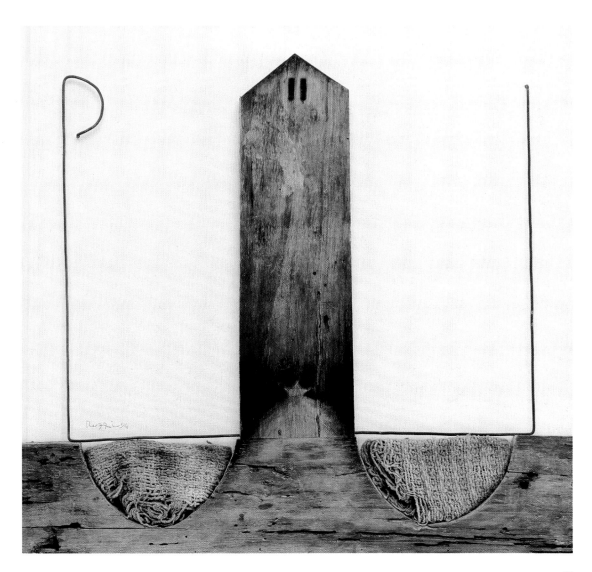

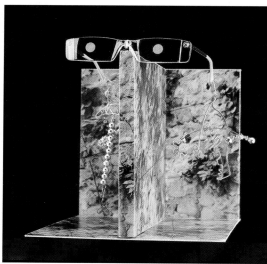

Maurizio Favetta,
È quasi primavera
(It's almost like spring),
mixed materials,
Milan 1994.

Nico De Sanctis,
Uno contro tutti
(One against all),
oil on wood,
Milan 1994.

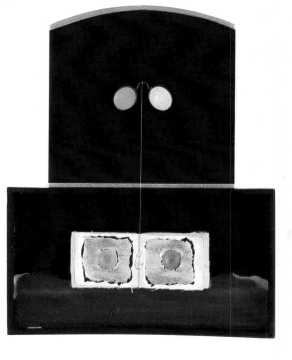

Pierpaolo Ramotto,
Equilibrio
(Balance),
wax, lead, mixed materials,
Perugia 1994.

74

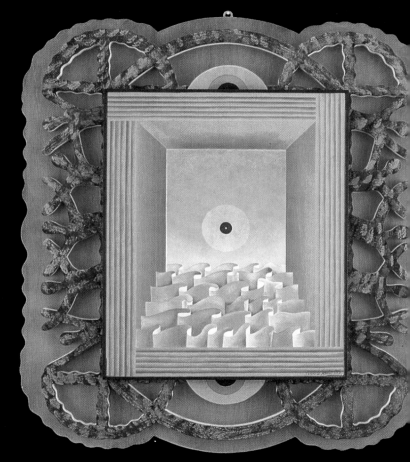

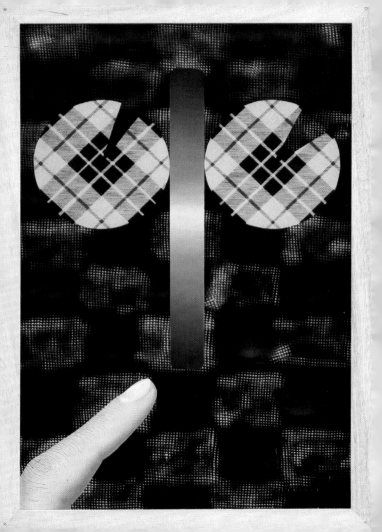

Thorsten Kirchoff,
*Senza titolo
(Untitled),*
metal and fabric,
Copenhagen 1993.

Manlio Caropreso,
*La svista
(Oversight),*
plastic and glass,
Milan 1995.

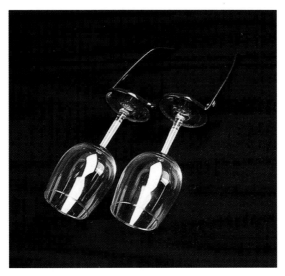

Maria Teresa Padula,
*Studiare il mondo
(World study),*
gesso, iron, wood,
Bari 1994.

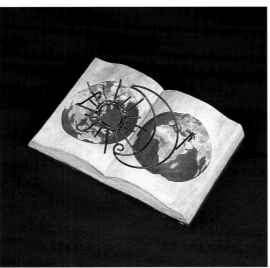

Lorenzo Mangili,
Corredo in rosa
(Pink Trousseau),
stone, plastic, glass, iron,
Bergamo 1995.

Antonella Tomasini,
Elefanti marini
(Sea elephants),
copper, glass, plastic,
Milan 1994.

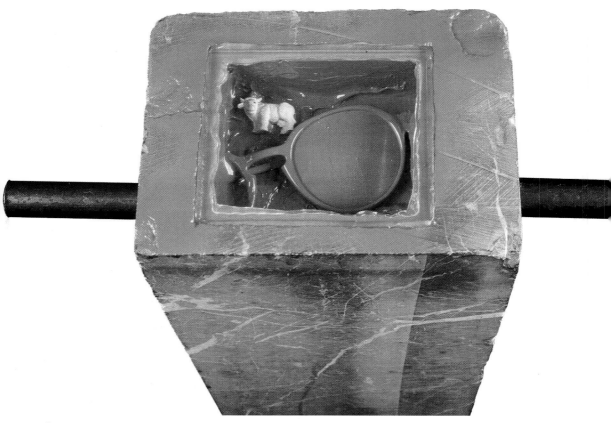

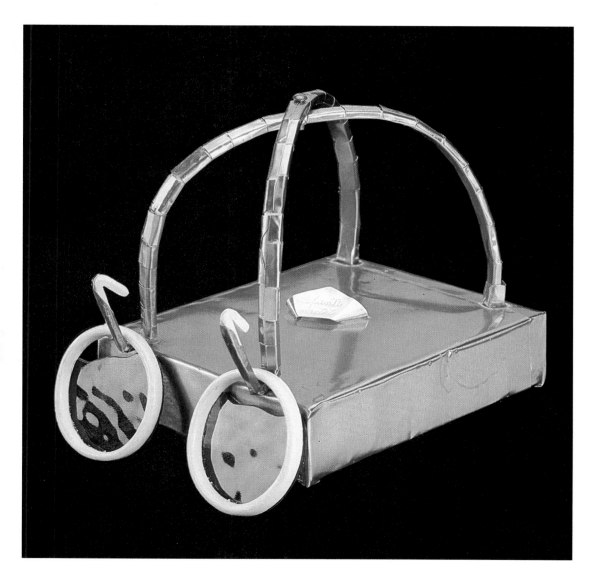

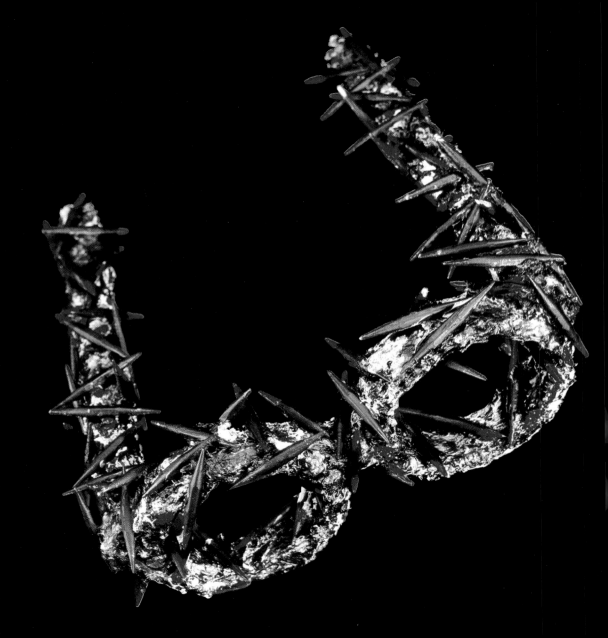

Philip Tsiaras
Jesus' glasses,
wood and tempera,
New York 1994.

Ben Jakober-Yannik Vu,
Gafas pro amnistia
(Spectacles for amnesty),
metal,
Mallorca 1985.

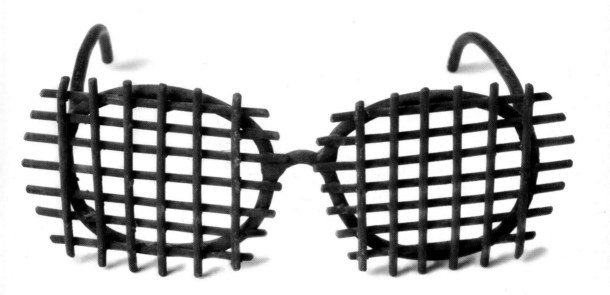

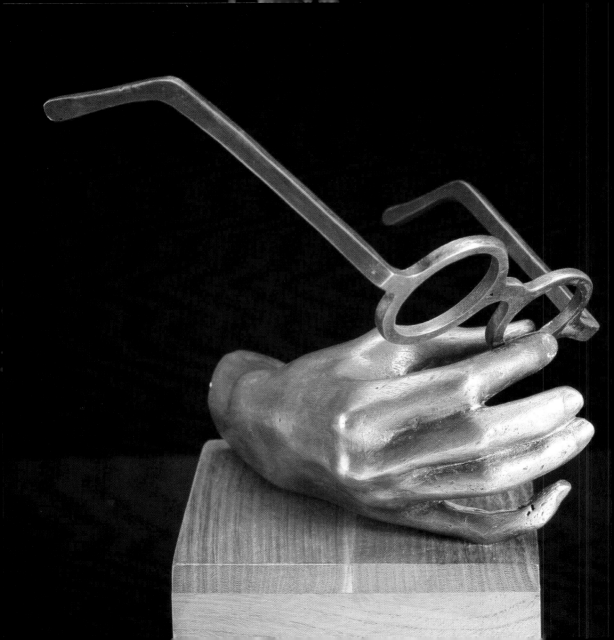

Fabio De Sanctis,
Ho occhi solo per te
(I only have eyes for you),
bronze and wood,
Rome 1994.

Gianluigi Antonelli
Lacrime versate
(Shed tears),
glass, plastic, vaseline,
Fermo 1995.

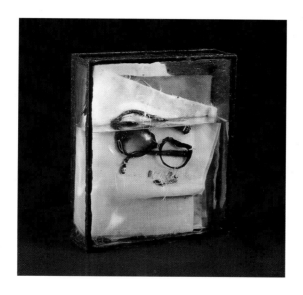

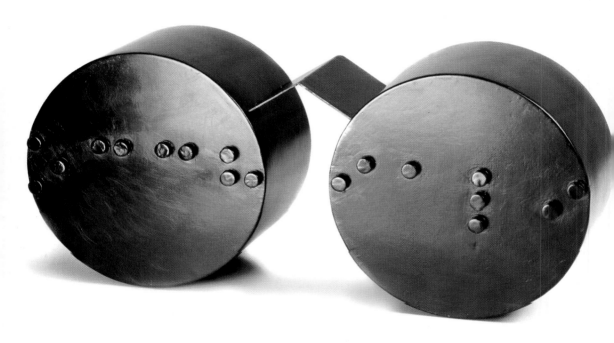

Roberto Lucca Taroni,
Il megalomane
(The megalomaniac),
wood, paper, metal,
Milan 1995.

Alba Gonzales,
La prospettiva
(Perspective),
cement, resin, wood, brass,
Rome 1993.

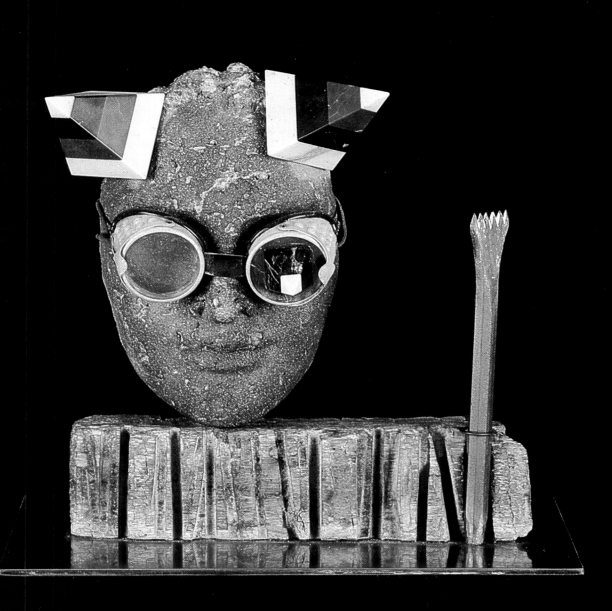

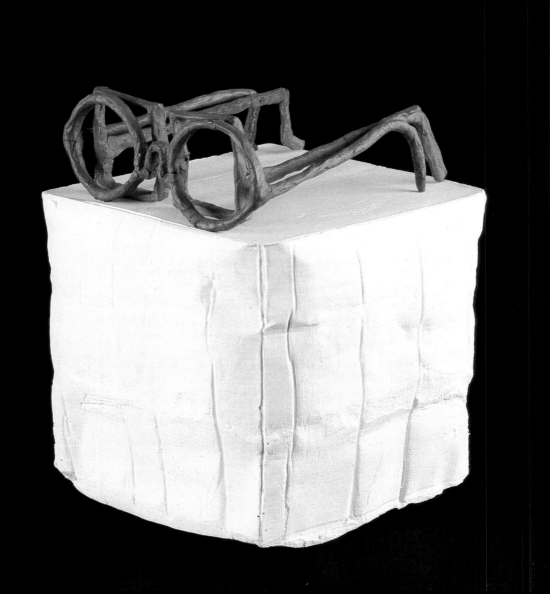

Yorgo Nikas
*Una coppia di occhiali
(Pair of glasses),*
gesso and terracotta
Paris 1994

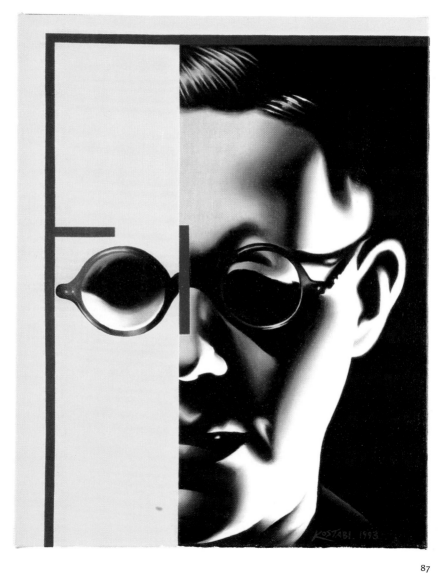

Marc Kostabi,
50%,
oil and canvas,
New York 1993.

Michele Lombardelli,
Moon glasses,
metal and tempera,
Piacenza 1994.

Gaetano Lo Monaco,
*4 occhi e 4 fanali
(4 Eyes and 4
Headlights),*
glass, fabric, silicone,
Florence 1994.

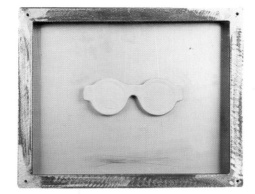

Sergio Borrini,
*Sguardo verso il cielo
(Eyeing the Sky),*
mixed materials,
Milan 1983.

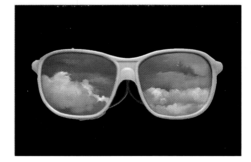

Delio Gennai,
*Occhio-barocchio
(Baroq-ular),*
wood, glass, fabric,
Pisa 1994.

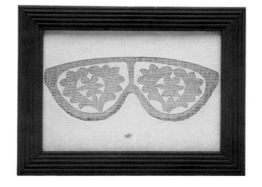

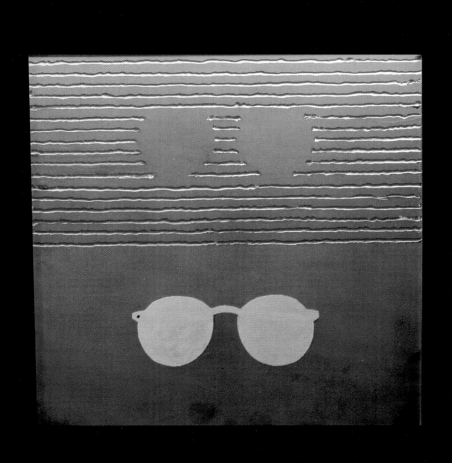

Glasses as tools not of correction but divination. Not as cumbersome prostheses,

LOOKING

but as wings on which to fly beyond reality. Not for seeing, but for predicting.

BEYOND

For looking beyond appearances, beyond a sight to sight itself.

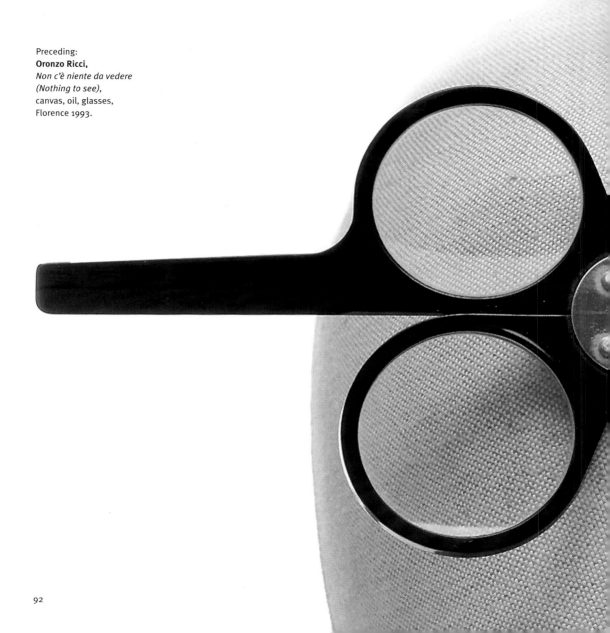

Preceding:
Oronzo Ricci,
Non c'è niente da vedere
(Nothing to see),
canvas, oil, glasses,
Florence 1993.

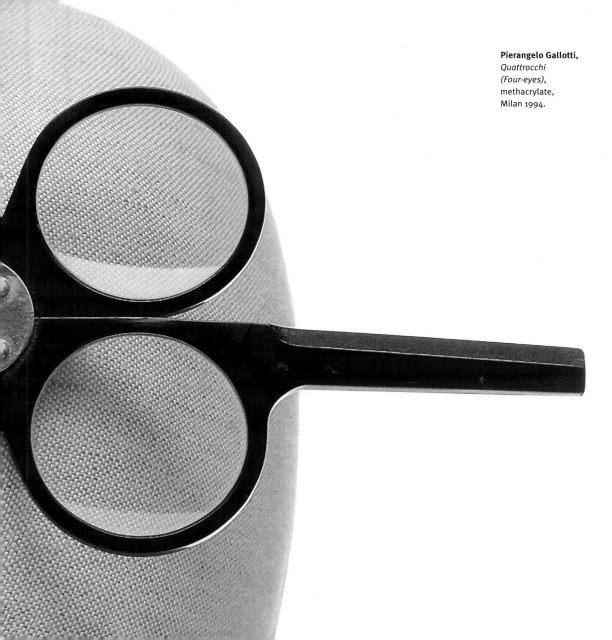

Pierangelo Gallotti,
*Quattrocchi
(Four-eyes),*
methacrylate,
Milan 1994.

Ugo La Pietra,
*Ipotesi di lente
(Conjectural lens),*
drawing,
Milan 1993.

Ugo La Pietra,
*Ipotesi di stanghette
(Conjectural earpieces),*
drawing,
Milan 1993.

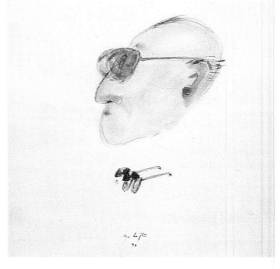

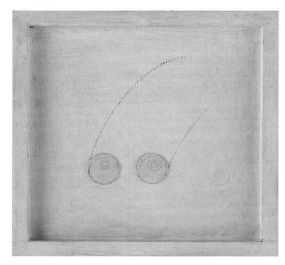

Arnaldo Sanna,
*Per non perdersi di vista
(Let's not Lose sight of
each other . . .),*
mixed media,
Milan 1993.

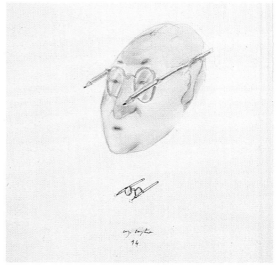

Di Somma e Giannotti,
Sonnambula
(Sleepwalker),
mixed materials,
Florence 1995.

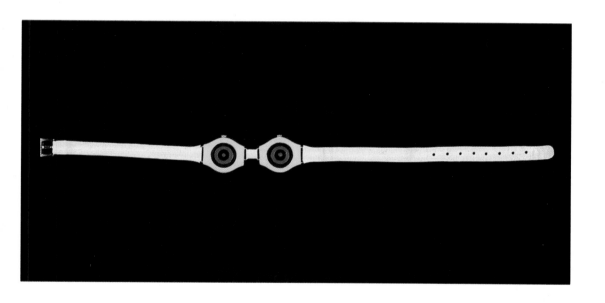

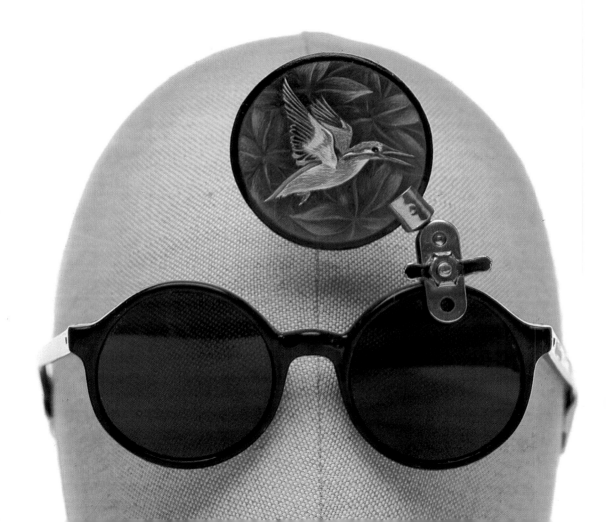

Mercurio Lo Grasso,
Sogno di volare
(A Dream of flight),
mixed materials,
Turin 1994.

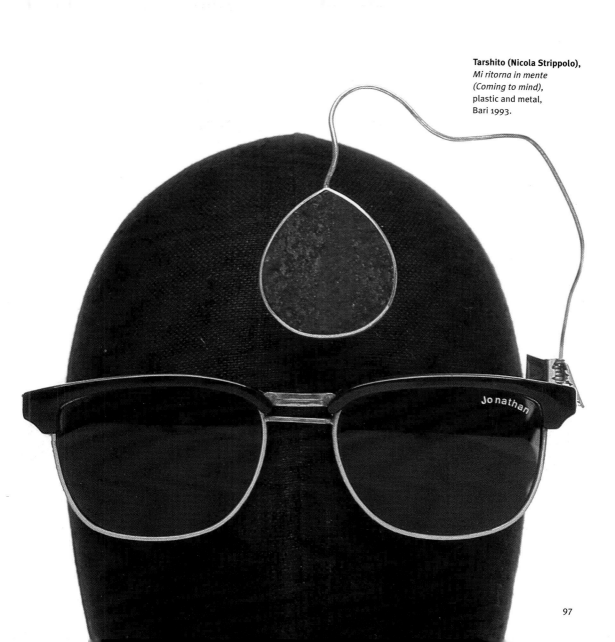

Tarshito (Nicola Strippolo),
*Mi ritorna in mente
(Coming to mind),*
plastic and metal,
Bari 1993.

Bruno Munari,
Occhiali paraluce
(Visor glasses),
thin cardboard,
Milan 1953–1990.

Ico Parisi,
Sguardo tagliente
(Cutting glance),
metal and holograms,
Como 1993.

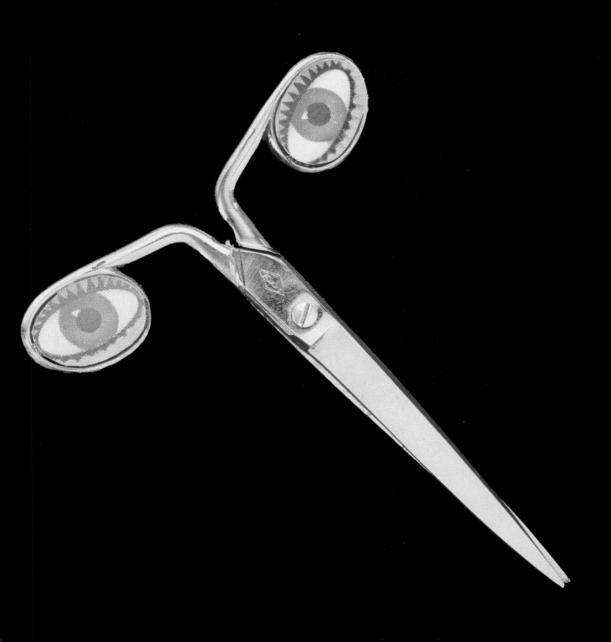

Teresa Sapey,
*Sognando ad occhi aperti
(Dreaming with your
eyes open),*
mixed materials,
Madrid 1994.

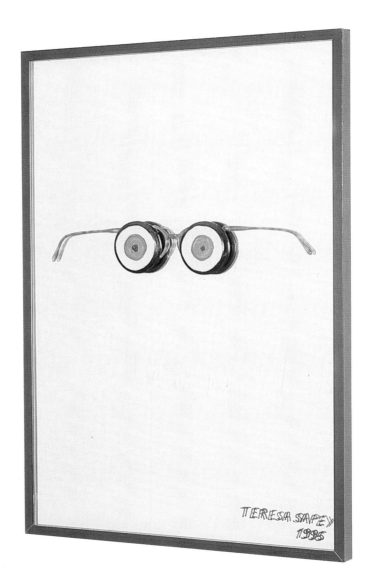

Bruno Hadjadj,
Le millionaire,
wood and mixed materials,
Paris 1994.

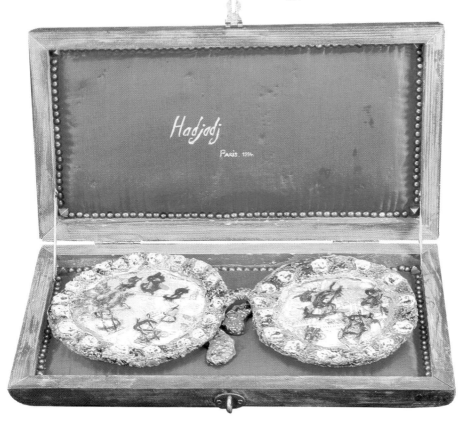

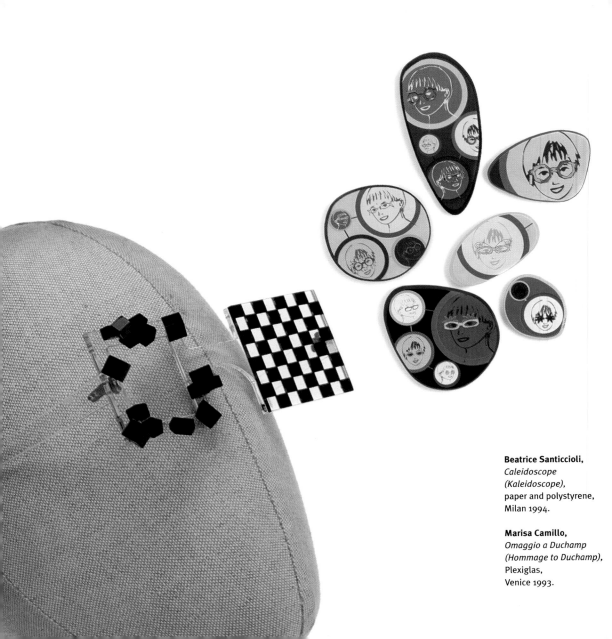

Beatrice Santiccioli,
*Caleidoscope
(Kaleidoscope),*
paper and polystyrene,
Milan 1994.

Marisa Camillo,
*Omaggio a Duchamp
(Hommage to Duchamp),*
Plexiglas,
Venice 1993.

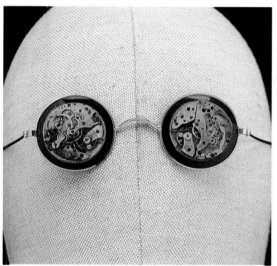

Francesca Della Valle,
*Non vedo l'ora
(Can't wait to see),*
metal,
Florence 1994.

Nadia Nava,
*La Venere confusa
(Venus confused),*
slate, glass, silver,
Milan 1994.

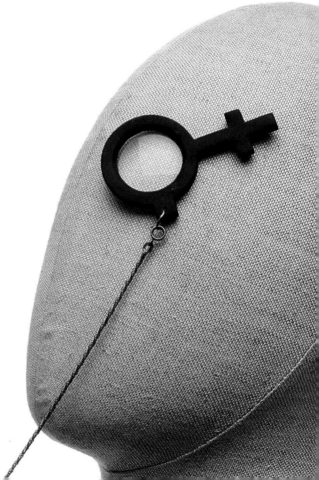

Mimmo Palmizi,
Congiunzione di due organi
(Converging Bodies),
ceramic, plexiglas, metal,
Milan 1993.

Isabella Santacroce,
L' illuminato
(Illuminatus),
iron, Plexiglas, wax, sheet metal,
Milan 1993.

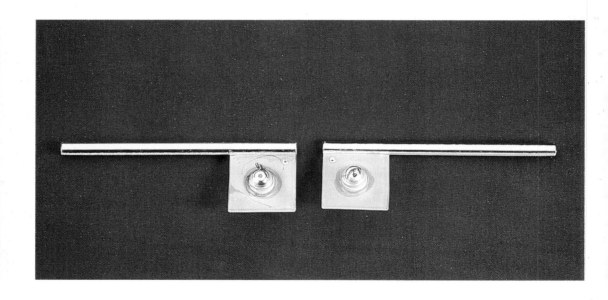

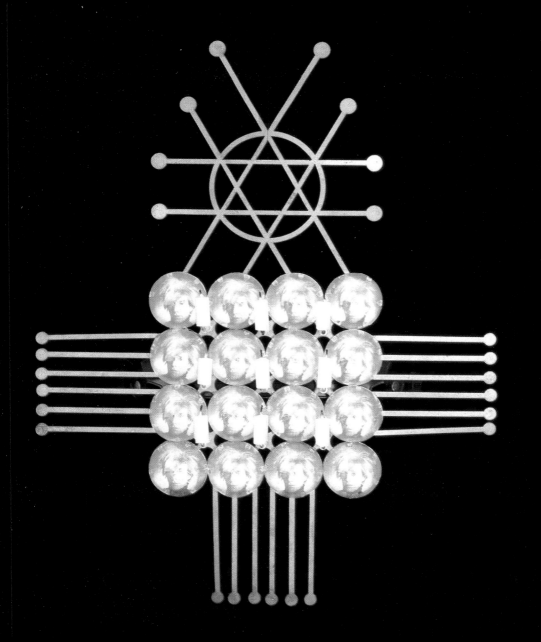

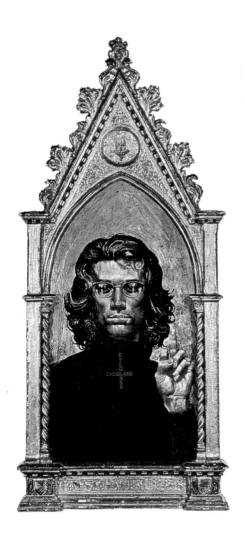

Angelo Vadalà,
*Visita ai musei vaticani
(At the Vatican museums),*
mixed materials,
Milan 1994.

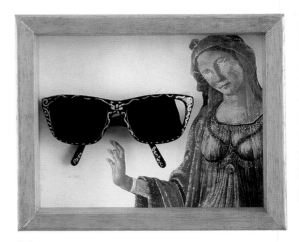

Ruiu,
*Beato chi non vede
(None so blessed as those
who do not see),*
mixed materials,
Milan 1993.

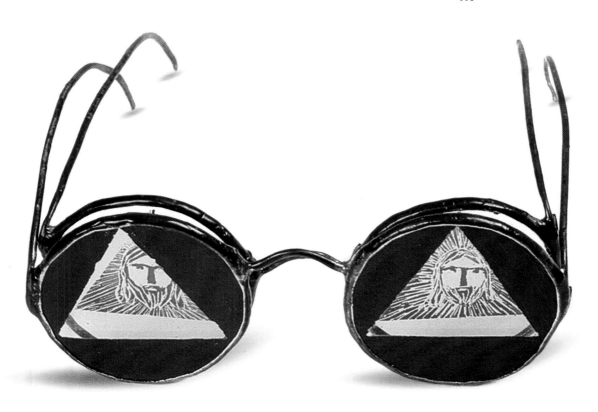

Irene Esposito,
*In cerca di un Dio
(Seeking God),*
glass and metal,
Milan 1995.

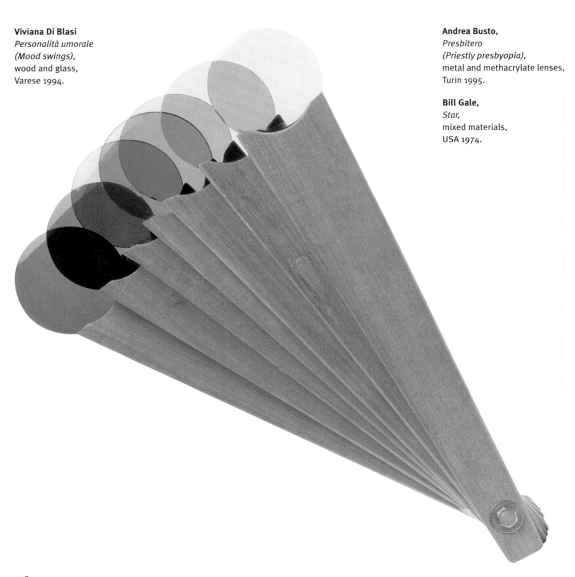

Viviana Di Blasi
Personalità umorale
(Mood swings),
wood and glass,
Varese 1994.

Andrea Busto,
Presbitero
(Priestly presbyopia),
metal and methacrylate lenses,
Turin 1995.

Bill Gale,
Star,
mixed materials,
USA 1974.

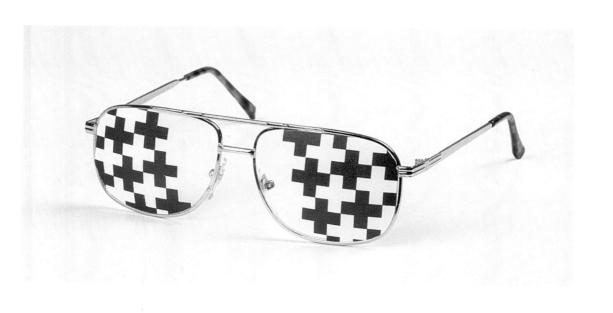

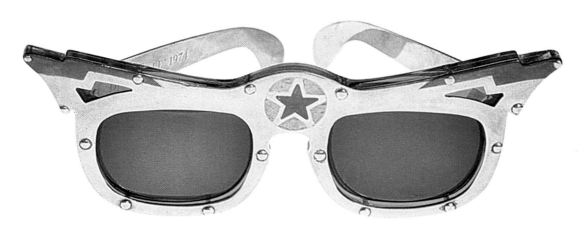

Francesco Cremoni,
Occhial-lacerato
(Glass-erated),
marble,
Carrara 1994.

Calugi e Giannelli,
Rhythm and blues,
mixed materials,
Florence 1993.

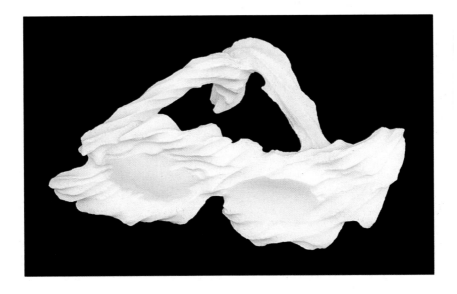

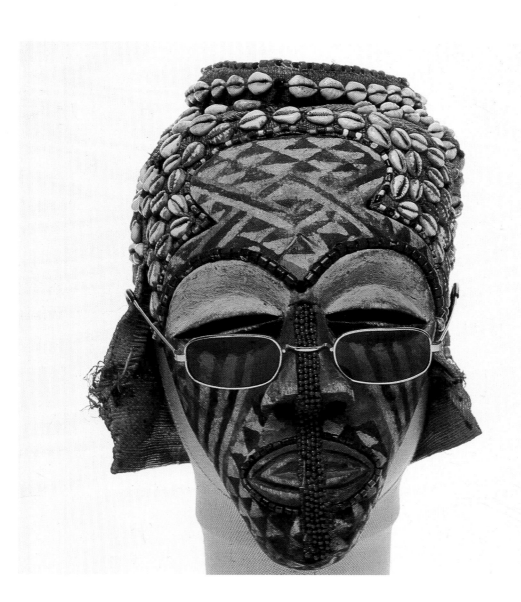

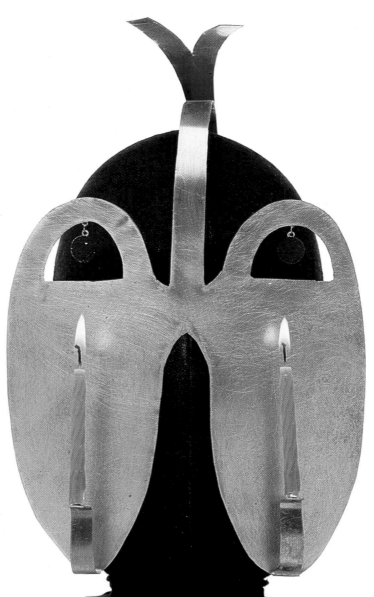

Gianni Mantovani,
*Per vederci meglio
(The better to see you
with, my dear),*
copper and wax,
Modena 1994.

Marcello Magnanelli,
*Mistero velato
(Veiled mystery),*
mixed materials,
Florence 1994.

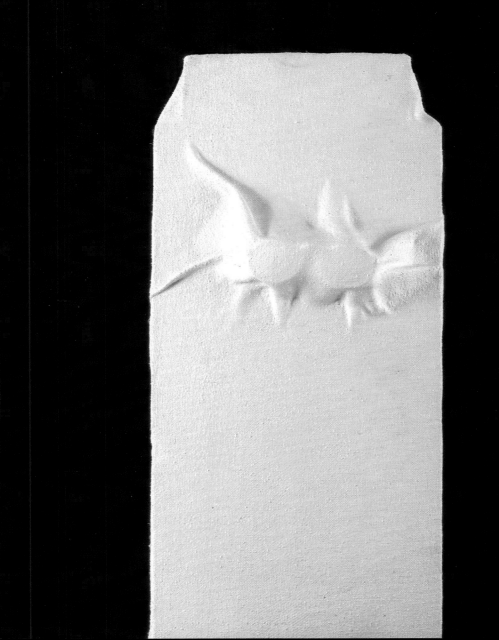

Gino Lucente for the Bank of Oklahoma,
Non rivedrai più quello che hai prestato
(That's the last you've seen of that money you lent),
self-portrait with optical materials,
Milan 1994.

Ivano Cerrai,
Flash Gordon,
metal and Plexiglas,
Florence 1993.

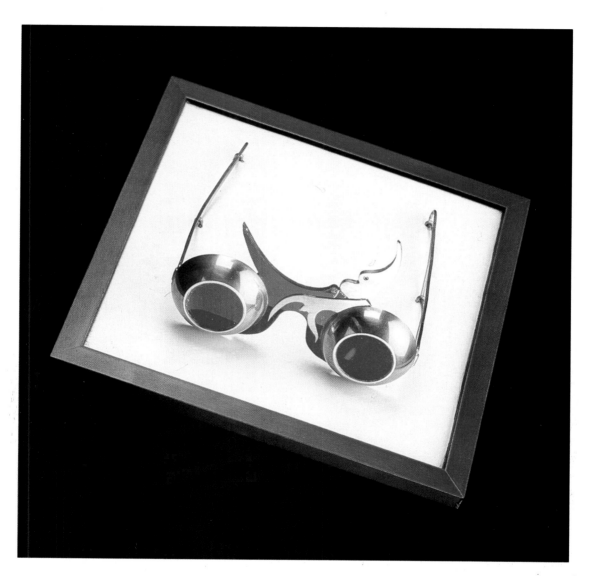

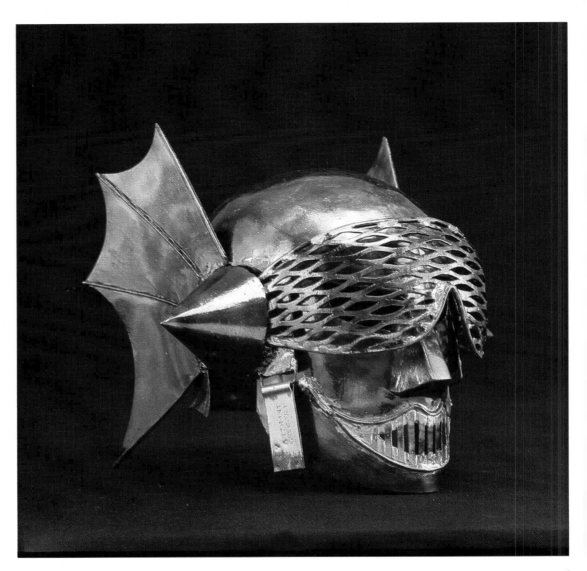

Anthony Gregory,
Love & Victory,
bronze,
London 1994.

Roberto Fallani,
*Occhi di gatta
(Cateyes),*
silver and stone,
Florence 1994.

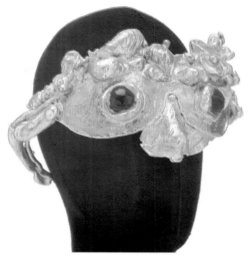

Nicola Salvatore,
*Punti blue
(Blue points),*
rubber and resin,
Como 1993.

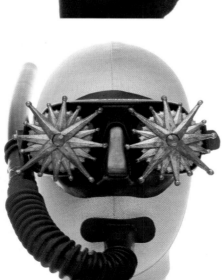

Matteo Cresti,
*Il suo nome era nessuno
(His name was Noman),*
wood and glass,
Florence 1994.

Luca Bertan,
Hook,
rubber and glass,
Merano 1995.

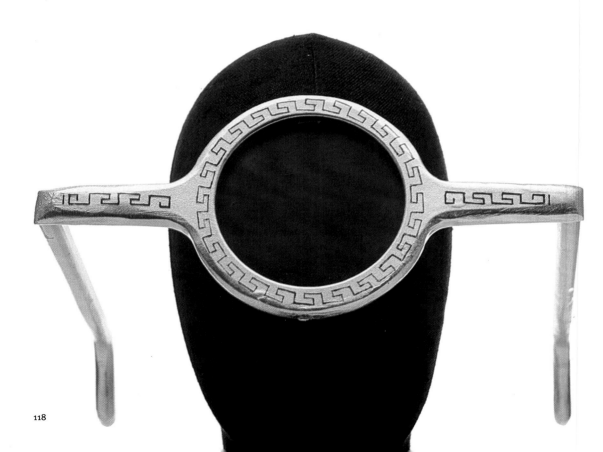

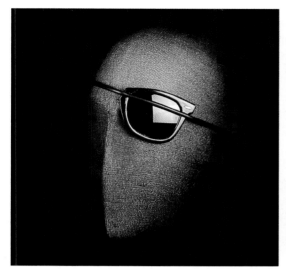

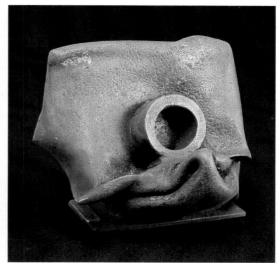

Davide Scarabelli,
*Polifemo
(Polyphemus),*
steel,
Modena 1994.

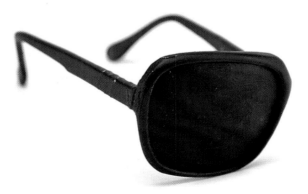

Claudio Destito,
*Per Polifemo
(For Polyphemus),*
acrylic on celluloid,
Turin 1993.

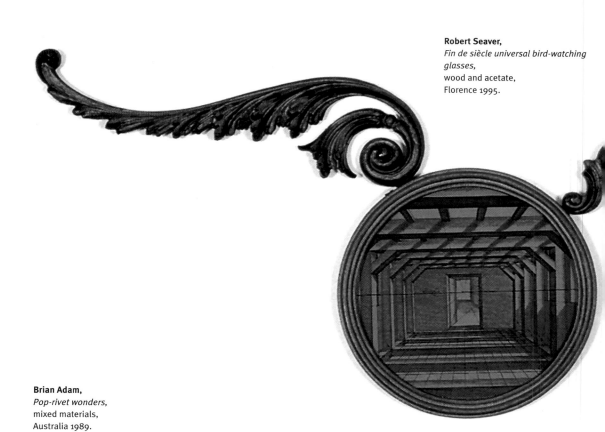

Robert Seaver,
Fin de siècle universal bird-watching glasses,
wood and acetate,
Florence 1995.

Brian Adam,
Pop-rivet wonders,
mixed materials,
Australia 1989.

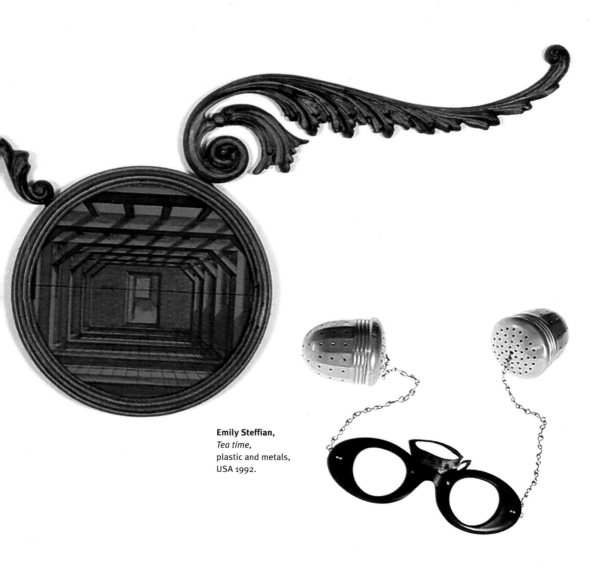

Emily Steffian,
Tea time,
plastic and metals,
USA 1992.

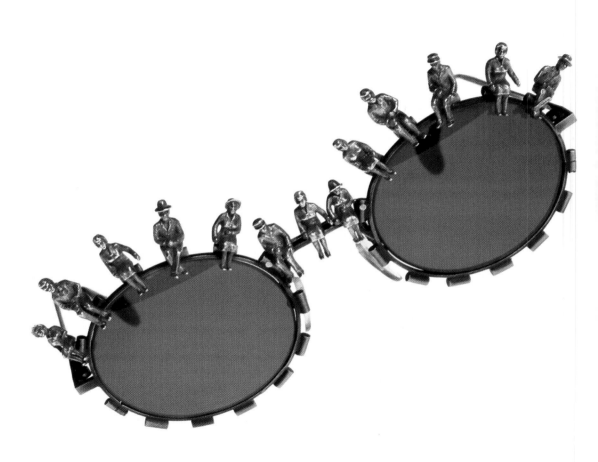

Seeing as a kind of journey: from dark to light, from nothing to substance.

LOOKING

Sight as crossing over. Bridges suspended to unite distant eyes in the fire of the lens.

OBLIQUELY

A look as a path towards an understanding of oneself and the other.

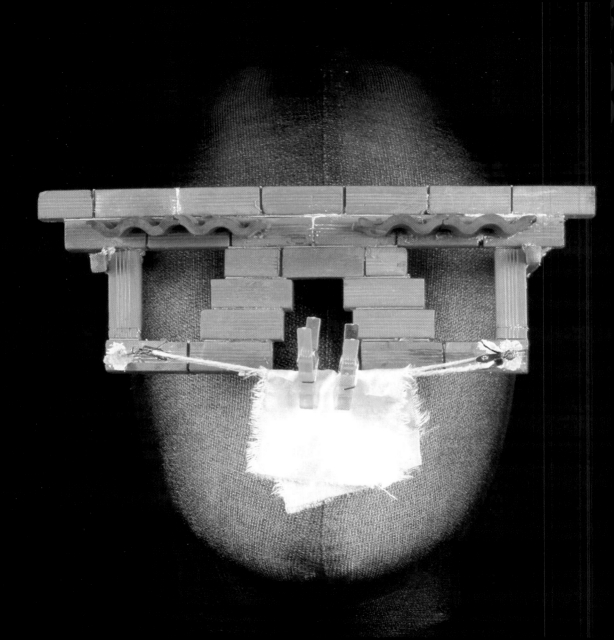

Preceding:
Deb Stoner,
Airport/birds on a wire,
silver and glass,
USA 1992.

Vicky Ambery-Smith,
Tower bridge, London,
mixed materials,
USA 1991.

Giuseppe Di Somma,
Borgo tegolai, 10
(#10 Tilemaker Alley),
terracotta and wood,
Florence 1995.

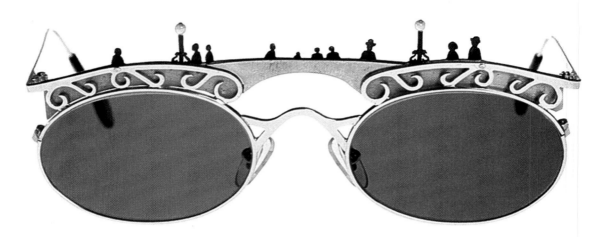

Vicky Ambery-Smith,
Pedestrian bridge,
mixed materials,
USA 1991.

Vicky Ambery-Smith,
Rialto bridge, Venice,
mixed materials,
USA 1991.

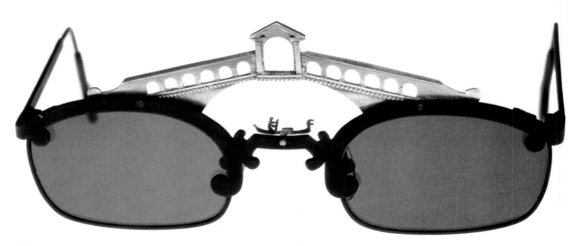

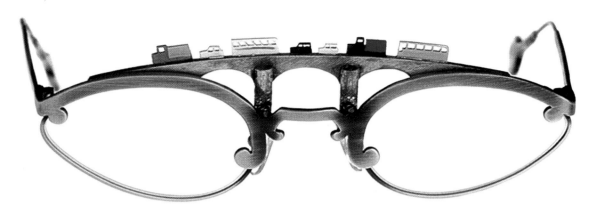

Vicky Ambery-Smith,
Ponte alla Carraia, Florence,
mixed materials,
USA 1991.

Vicky Ambery-Smith,
Ponte Vecchio, Florence,
mixed materials,
USA 1991.

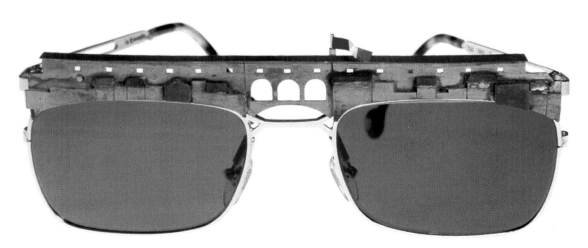

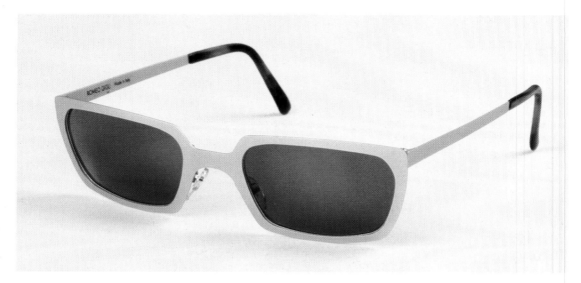

Romeo Gigli,
*Cromatismo
(Chromatism)*,
metal and glass,
Milan 1995.

Giorgio Vigna,
Cats,
silver,
Milan 1995.

Adam Shirley,
Untitled,
silver and mixed materials,
USA 1992.

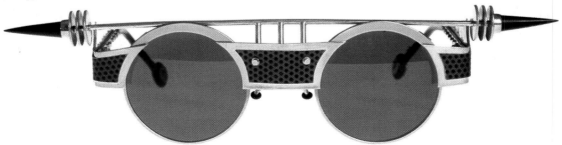

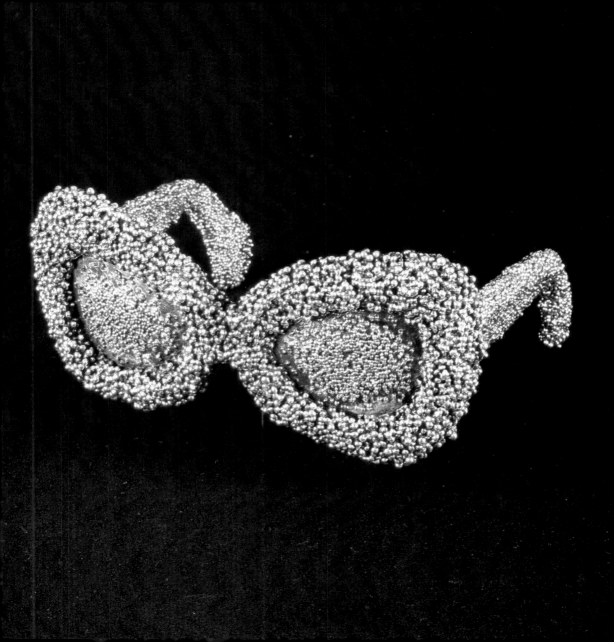

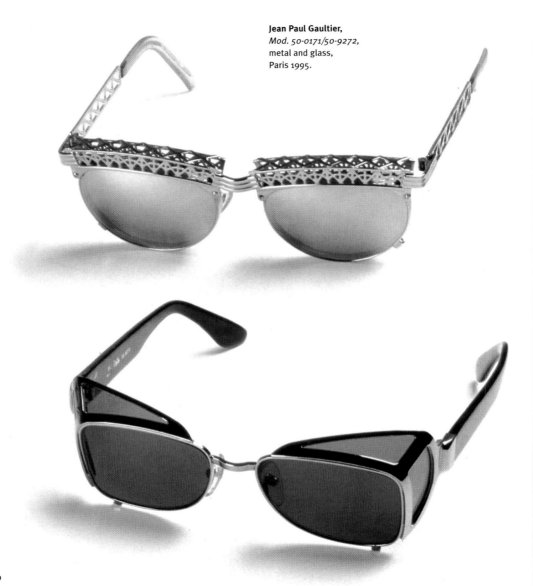

Jean Paul Gaultier,
Mod. 50-0171/50-9272,
metal and glass,
Paris 1995.

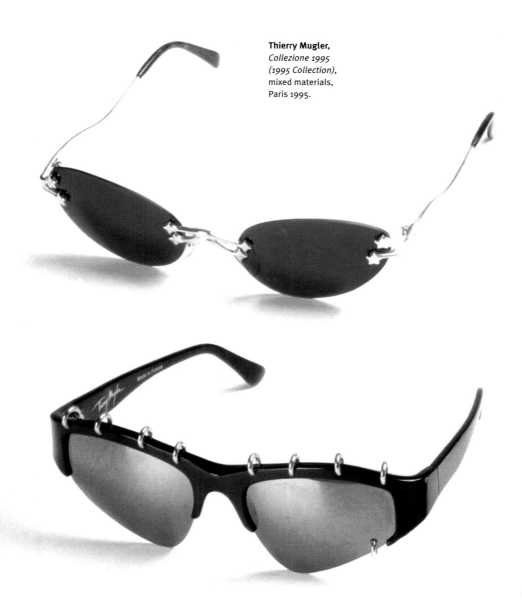

Thierry Mugler,
*Collezione 1995
(1995 Collection),*
mixed materials,
Paris 1995.

Paolo Cotza,
Dualità
(Doubles),
bronze and Plexiglas,
Turin 1995.

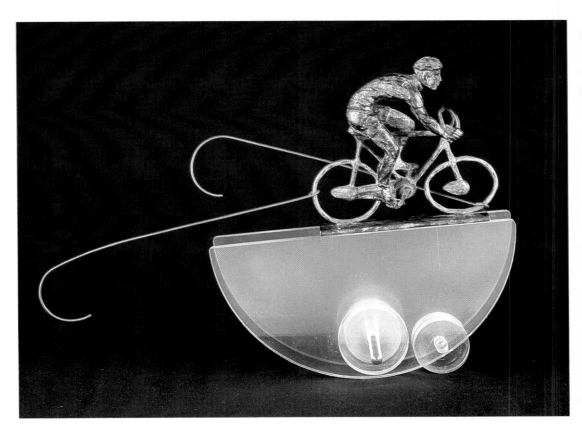

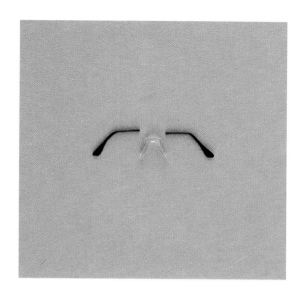

Carlo Bottinelli Montandon,
*A perdita d'occhio
(Out of sight),*
felt and mixed materials,
Como 1993.

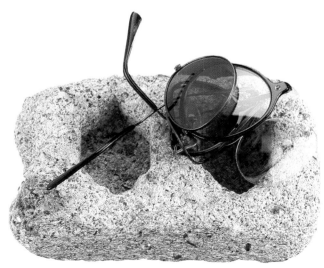

**Alice Nicola Console
Mangano and 2 x L**
*Passaggio per Milano
(A Stroll through Milan),*
stones and glasses,
Milan 1994.

Paolo AngeloSanto,
Occhi-alate, omaggio a Zeus
(Winged Eyes, homage to
Zeus),
metals,
Frosinone 1994.

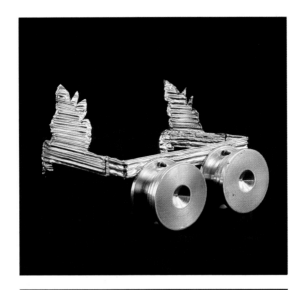

Domenico Borrelli,
Lucida follia
(Clear-eyed madness),
metal,
Turin 1993.

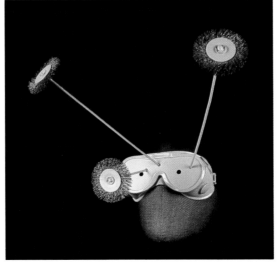

Brian Adam,
Eye strainers,
mixed materials,
USA 1993.

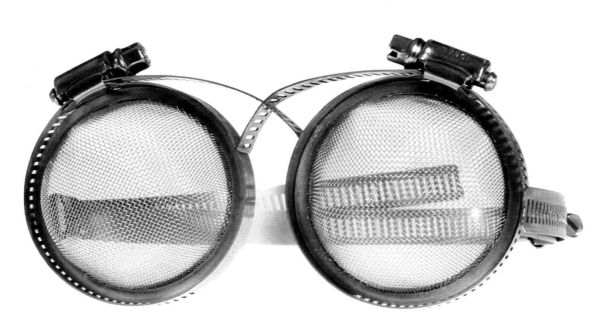

William Xerra,
Vive,
aluminum, iron, glass, paint,
Piacenza 1994.

Tonino Sanfilippo,
Strade da percorrere
(Miles to go),
Rubber and metal,
Florence 1995.

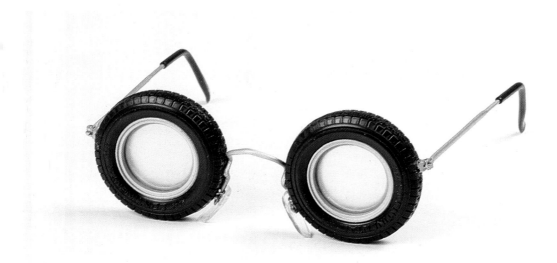

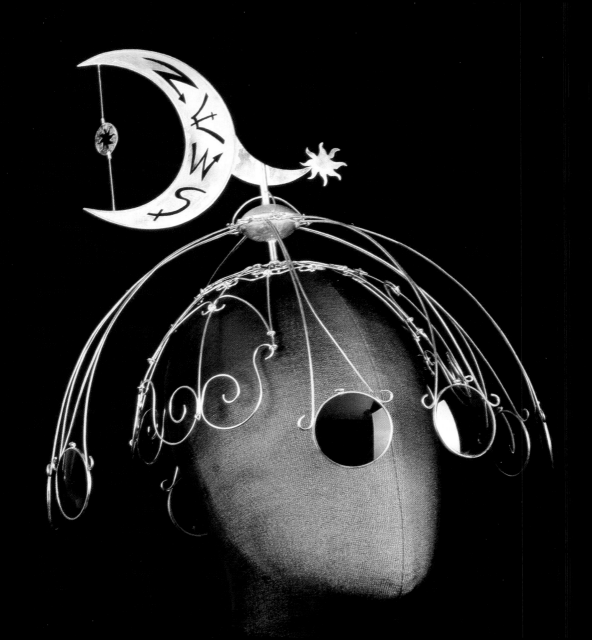

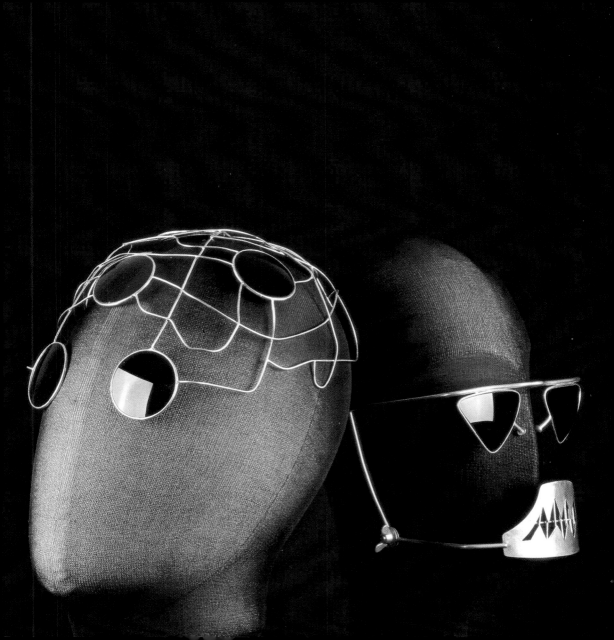

Preceding:
Pascal Lacotte / I.D.C.,
*Lo sguardo nel vento
(Weather-vane eyes),*
metal and glass,
Marseille 1995.

Stéphane Sarnin,
Mask,
metal and glass,
Paris 1993.

Graziano Spinosi,
*Orizzonte
(Horizon),*
oxidized copper,
Rome 1994.

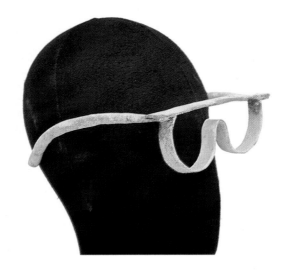

Make,
*Mi rimbalza uno e due
(It bounces on me, one and two),*
India rubber and polyethylene,
Florence 1993.

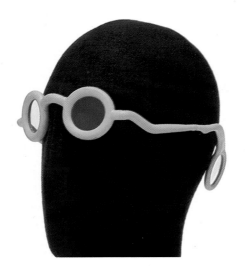

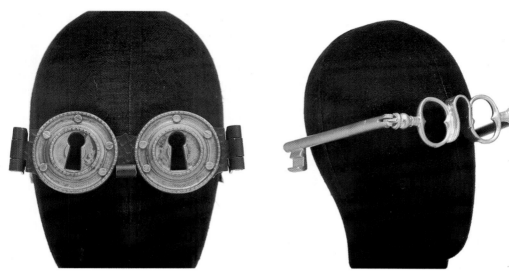

Giuseppe Piccione,
Indiscrezione
(Indiscretion),
metal,
Siracusa 1994.

Antonio Dattis,
Occhiavi
(Locked eyes),
metal,
Taranto 1993.

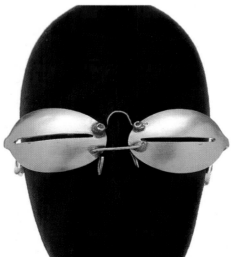

Enrico Prometti,
Made in China,
metal,
Milan 1994.

Stéphane Sarnin,
*Homage a Betty Page
(Homage to Betty Page),*
leather and metal,
Paris 1993.

Federica Ceppellotti,
*La centralinista
(Switchboard operator),*
glass, copper, tin foil,
Milan 1995.

Stéphane Sarnin,
*Preso di mira
(Taking sight),*
metal and glass,
Paris 1994.

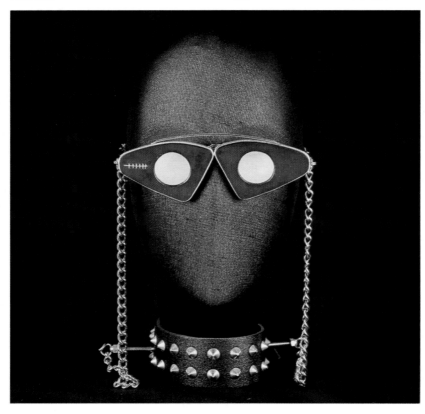

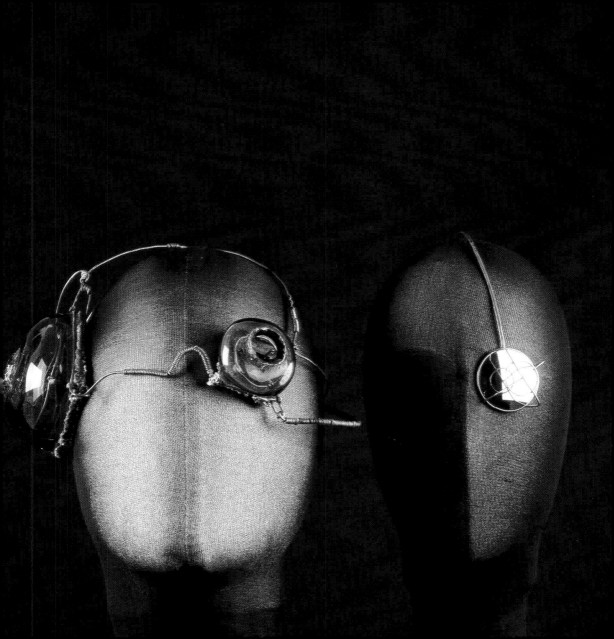

Ezio Gribaudo,
Occhiali
(Glasses),
mixed materials,
Turin 1995.

Federica Marangoni,
Occhio non vede cuore non duole
(The heart doesn' t suffer what
the eye doesn' t see),
mixed materials,
Venice 1993.

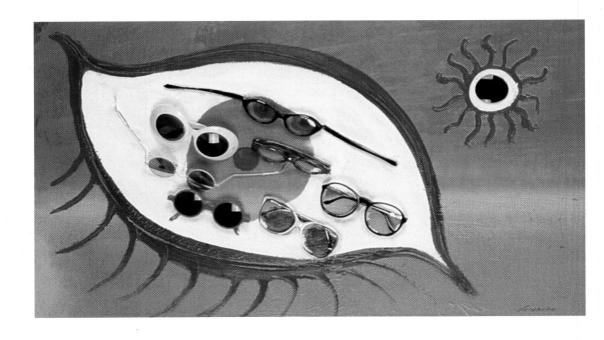

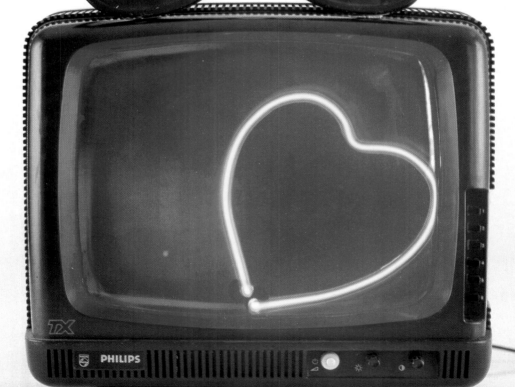

Claudia Kreile,
Rauf und runter (sù e giù)
(Up and down),
silver and gold,
Munich 1994.

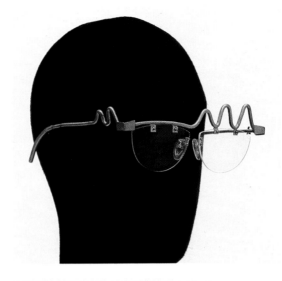

Pietro Boccardi,
Languido e contorto
(Languishing and twisted),
iron and glass,
Bergamo 1994.

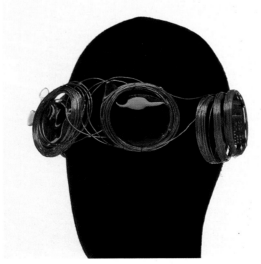

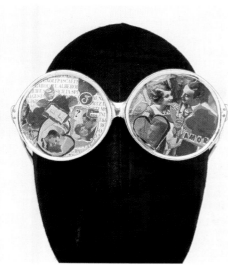

Antonio Arevalo,
*Memoria visiva
(Visual memory),*
mixed materials,
Rome 1994.

Luca Scacchetti,
*La città ideale
(The ideal city),*
Glass, brass, cherry-wood,
Milan 1994.

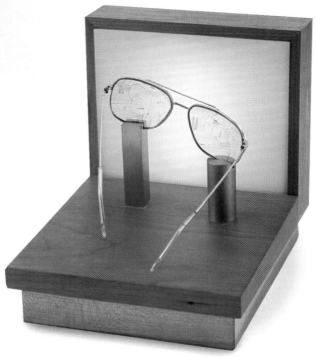

Following pages:
Paolo Grassino,
*Luce dei miei occhi
(Light of my life),*
plastic and glass,
Turin 1993.

Antonio Cagianelli,
*Sguardo infuocato
(Eyes afire),*
mixed materials,
Paris 1994.

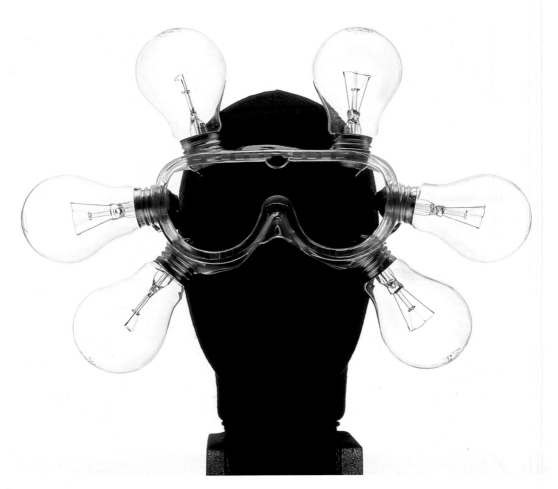

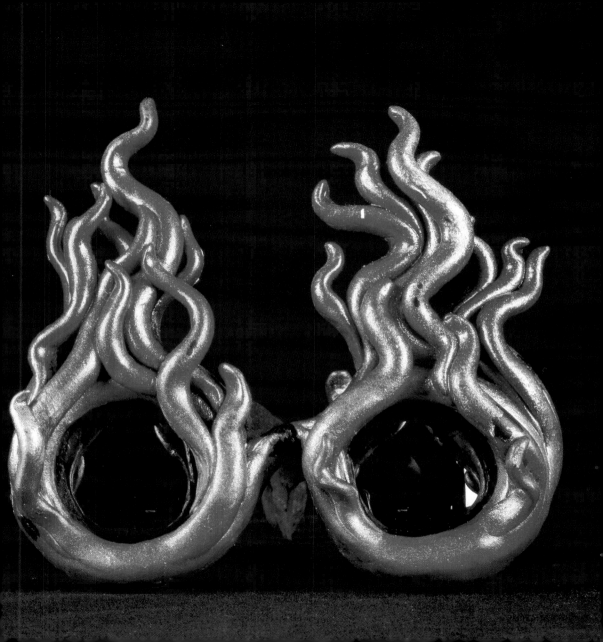

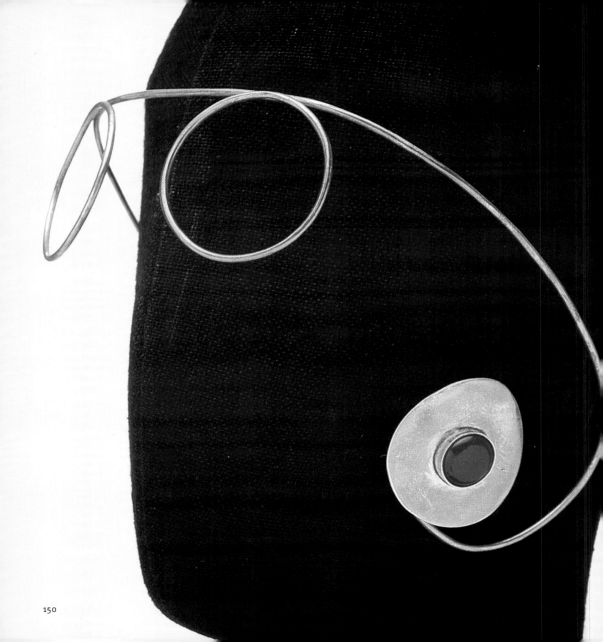

SEEING

Frames of baroque and rococco spirals, both constructivist and deconstructivist,

AND

which overflow onto the lens. Emphatic glasses to give sight of the view that is out of the

SEEING

ordinary, to make seeing extraordinary. Glasses as decorations to unveil new aesthetic horizons.

BEYOND

Preceding:
Silvia Borghi,
Orecchiali
(Eyerings),
silver and cornelians,
Como 1993.

Maria Agata Aiello,
L' eclisse
(Eclipse),
iron and glass,
Arezzo 1993.

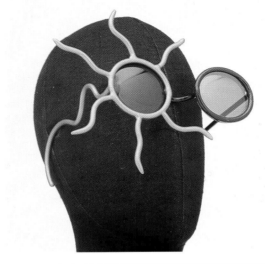

Joyce Scott,
Untitled,
mixed materials,
USA 1988.

Marco Lucidi Pressanti,
Oh my god,
plastic and paper,
Florence 1995.

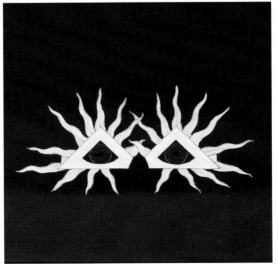

Hilary Beane,
Untitled,
plastic and metal,
USA 1990.

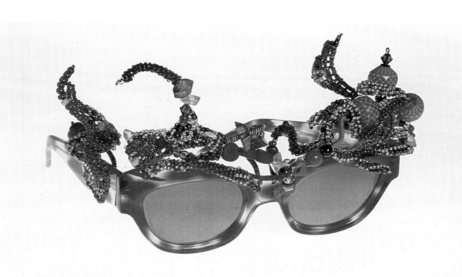

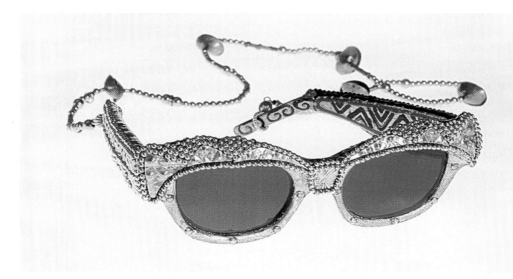

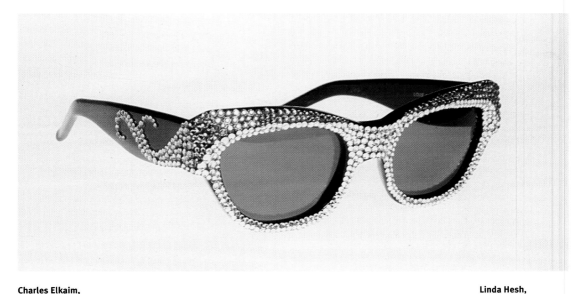

Charles Elkaim,
Crystal/black,
mixed materials,
USA 1988.

Linda Hesh,
Just a bad day,
silver,
USA 1991.

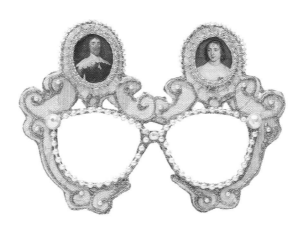

Shaun Clarkson,
Gold braid,
silver and cornelians,
Como 1993.

Mary Beth Rozkewicz,
Untitled,
silver,
USA 1993.

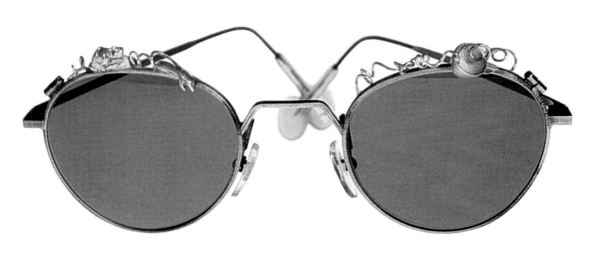

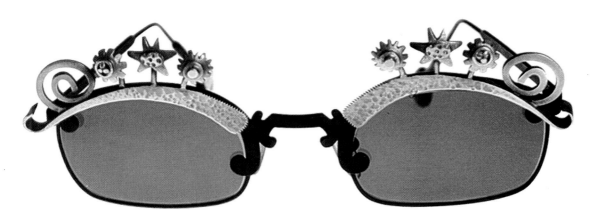

David Spada,
Untitled,
plastic, aluminum, rubber,
USA 1988.

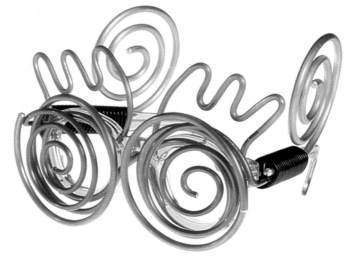

David Spada,
Untitled,
plastic, aluminum,
mixed materials,
USA 1988.

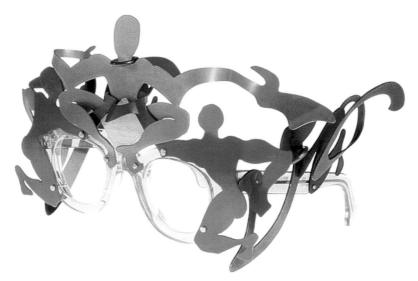

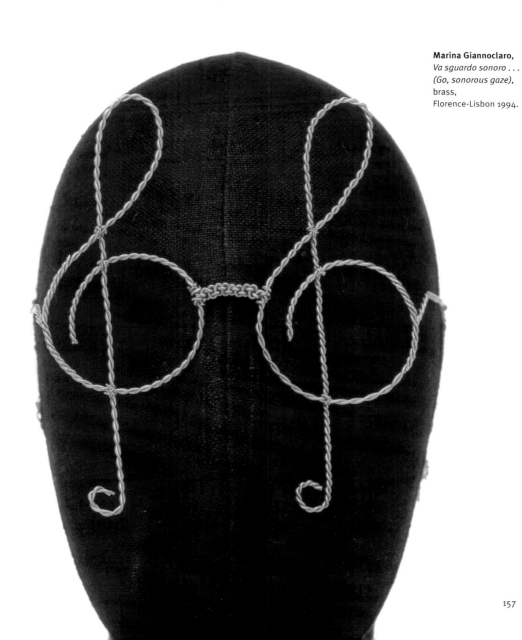

Marina Giannoclaro,
Va sguardo sonoro . . .
(Go, sonorous gaze),
brass,
Florence-Lisbon 1994.

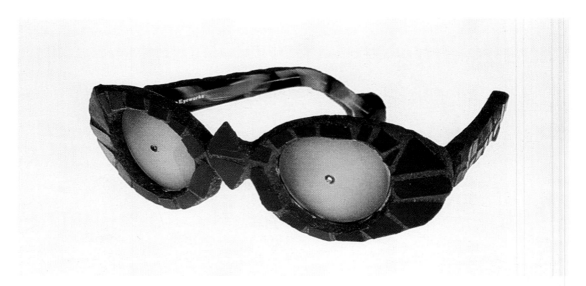

Amedeo Lanci,
*Sguardo Languido
(Languid glances),*
papier-mâché,
Florence 1993.

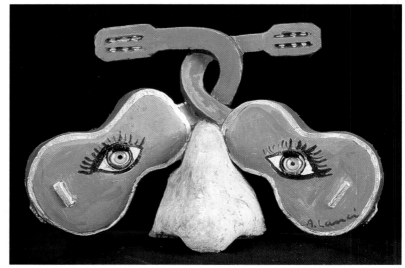

Giuseppe Arcofora
Visita ai musei vaticani
(At the Vatican museums),
metal and glass,
Florence 1994.

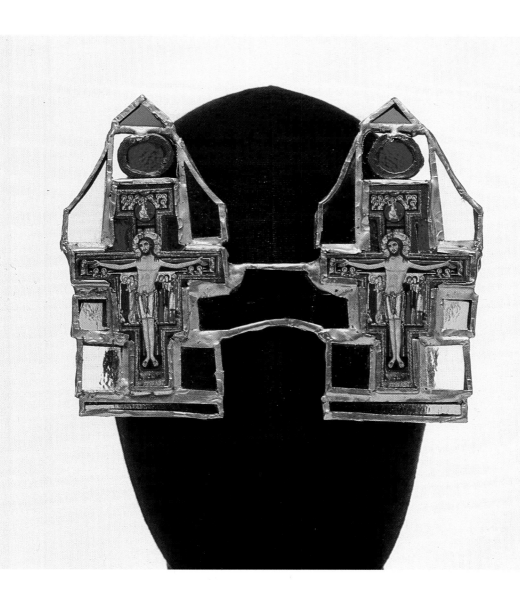

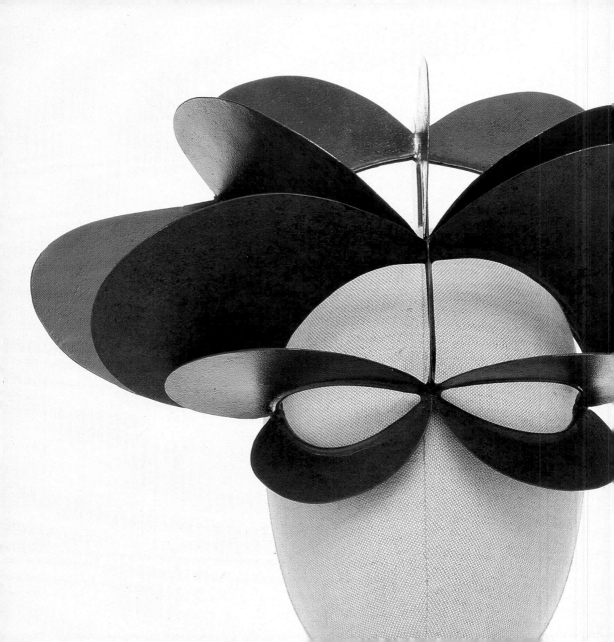

Walter Francone,
Natura viva
(Unstill life),
copper and brass,
Como 1993.

Giuseppe Ricci,
Betty Boop,
celluloid, synthetic fiber, metal,
Milan 1994.

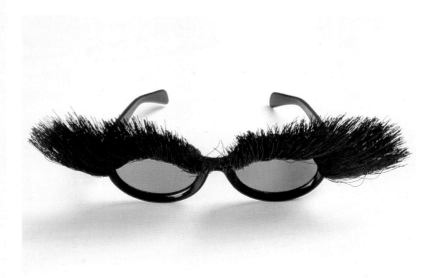

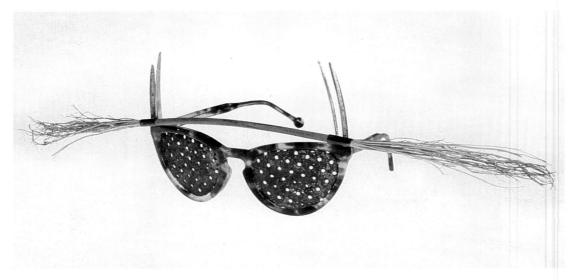

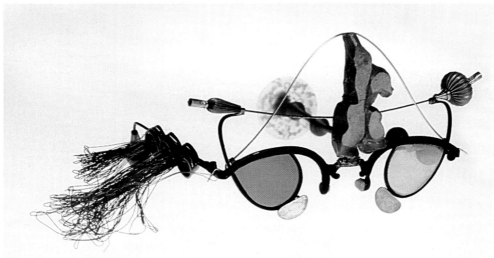

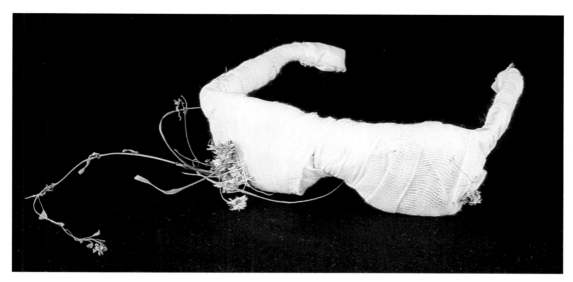

Marcia Macdonald,
Untitled,
mixed materials,
USA 1992.

Giovanni Rizzoli,
*Dopo
(Afterwards),*
Gauze, flowers, plastic,
Venice 1995.

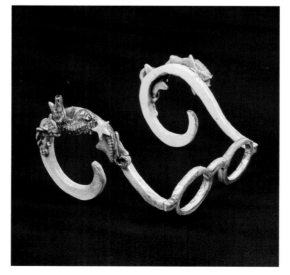

Vernon Theiss,
*Visions of another man . . .
reality or illusion, etc.,*
ebony, silver, mixed materials,
USA 1992.

Rosy Meli e Silvia Manna,
Antinea,
ceramic,
Formia 1993.

Rosemarie Sansonetti,
*L' arte di vedere
(Art of seeing),*
glass, paper, wood,
Bari 1994.

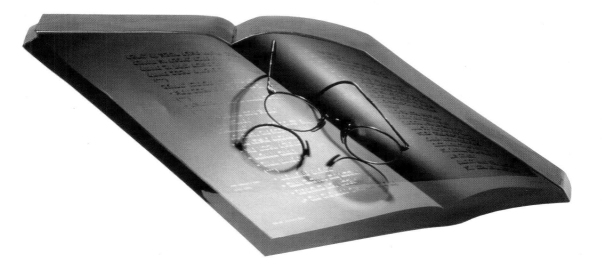

Silvio Wolf,
*Il libro delle parole
(The book of words),*
cibachrome, enamels, laminated polystyrenes,
Milan 1995.

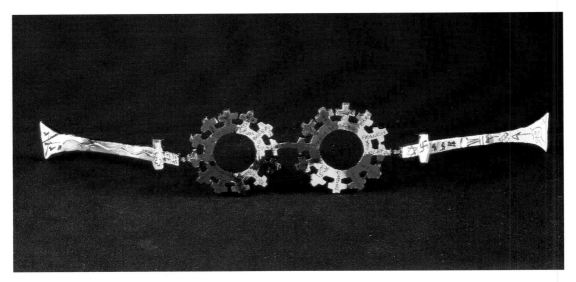

Mirella Iacovangelo,
Testimone oculare3
(Eye witness3),
wood,
Bergamo 1994.

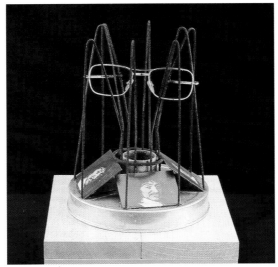

Ernesto Jannini,
Ritratto di cartesio con
gli occhiali
(Portrait of Descartes
with glasses),
metal, glasses, color photos,
Milan 1994.

Giulio Telarico,
Attraverso . . .
(Through . . .),
mixed materials,
Cosenza 1994.

Massimo Osti,
Flexible,
metal and glass,
Asolo 1995.

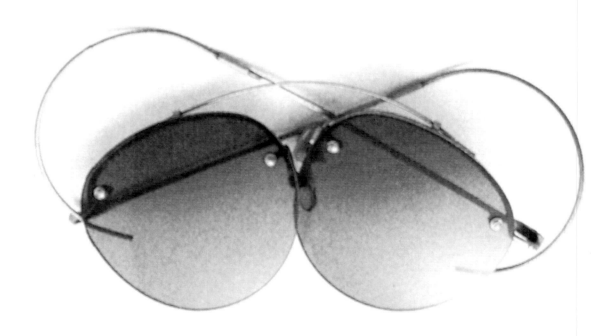

Ellen Weiske,
Untitled,
metal,
USA 1992.

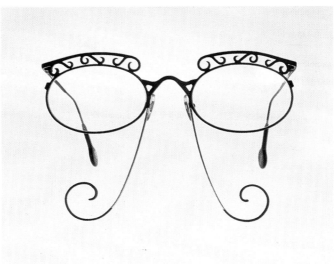

Gai Gherardi &
Barbara Mc Reynolds,
Magdanan,
metal,
USA 1990.

Gianfranco Ferré,
Mod. 4ff264/5,
metal and glass,
Milan 1995.

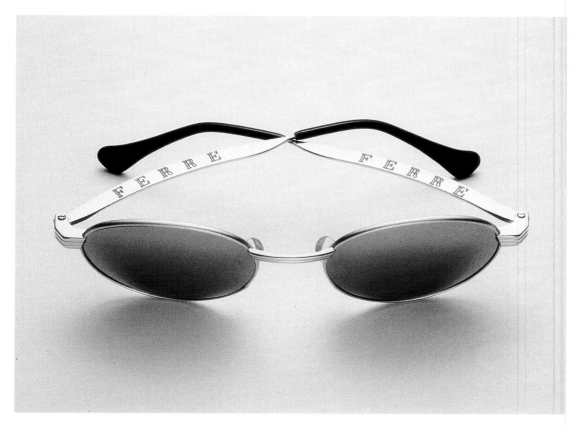

Paolo Brenzini,
Luigi XV
(Louis XV),
plastic, enamel, terracotta,
Massa 1995.

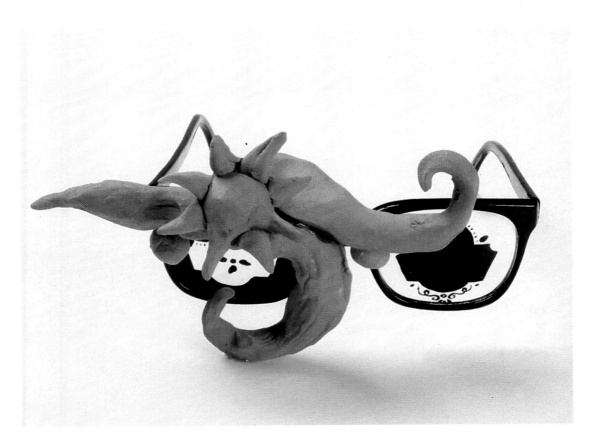

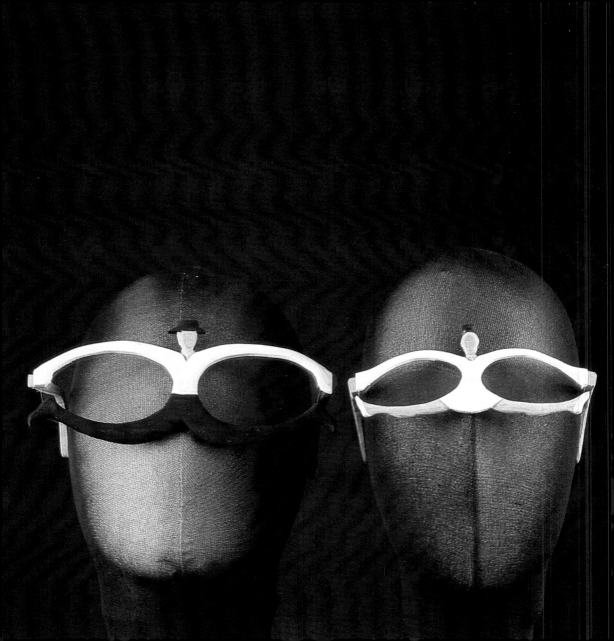

MEN

Anthropomorphism and zoomorphism. Affective glasses, fetishes to be contemplated and to

AND

enflame. Shapes of cats, butterflies, and other animals to

OTHER

render glasses domestic. Frames that fold like a supple body to make vision dynamic.

ANIMALS

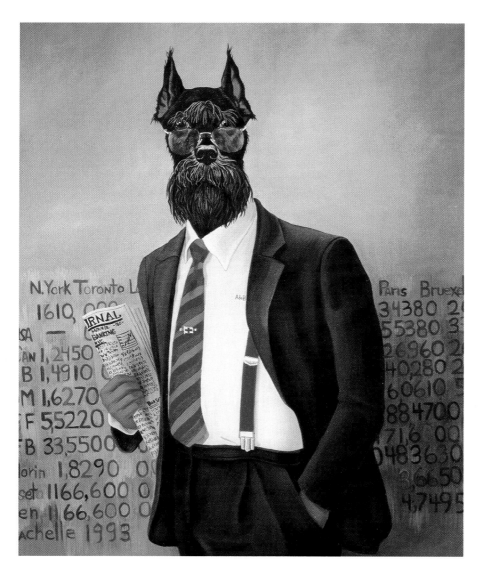

Preceding:
Samuele Mazza,
*Danza di sguardi
(Dancing eyes),*
wood and plastic,
Milan 1994.

Rachelle Oatman,
Business dog,
oil on canvas,
Milan 1993.

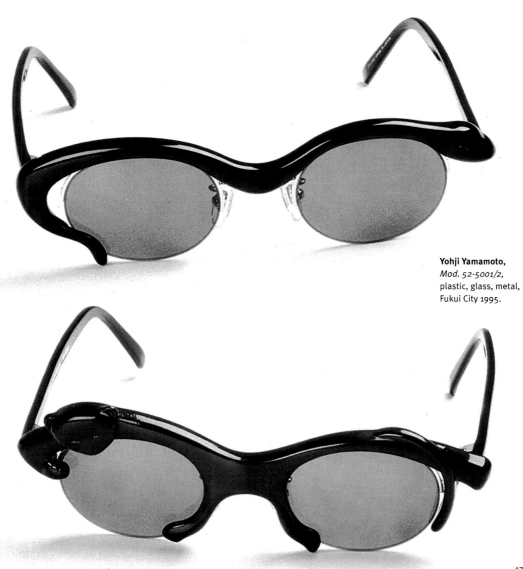

Yohji Yamamoto,
Mod. 52-5001/2,
plastic, glass, metal,
Fukui City 1995.

Ogata,
The crying games,
Persian travertine marble,
La Spezia 1993.

Rhonda Sabof,
Head of Dick Smith,
mixed materials,
USA 1993.

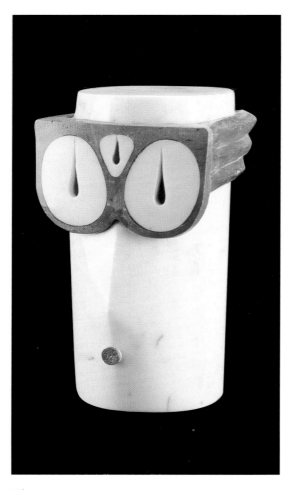

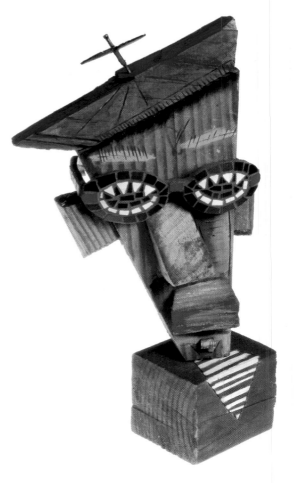

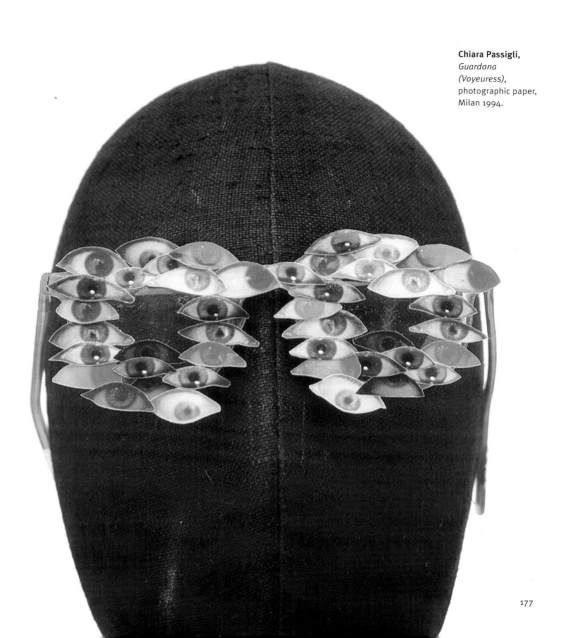

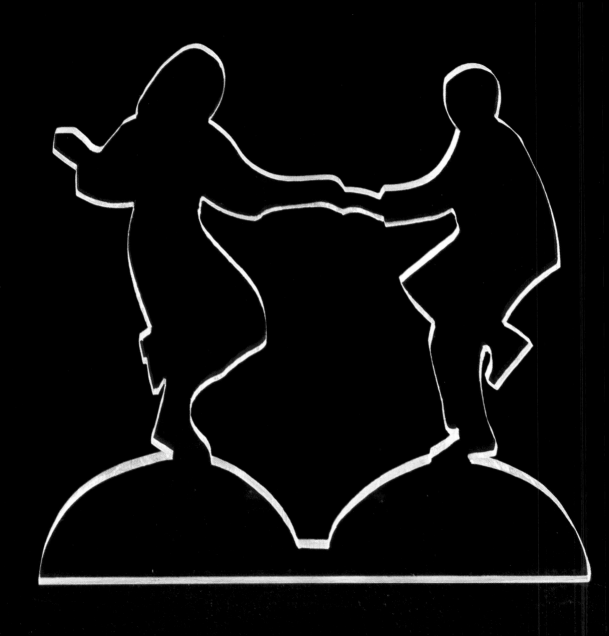

Marco Lodola,
Lenti
(Slow lenses),
Perspex,
Pavia 1994.

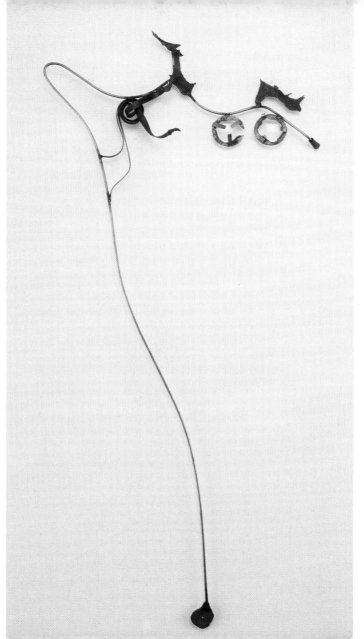

Angela e Giovanni
Grimoldi,
L' occhiale del gufo
(Owl glasses),
iron and lenses,
Varese 1994.

Stéphane Sarnin,
*Minotauro
(Minotaur),*
leather and synthetic fur,
Paris 1994.

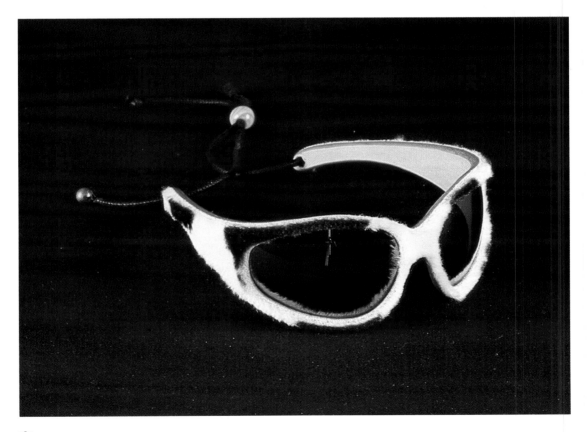

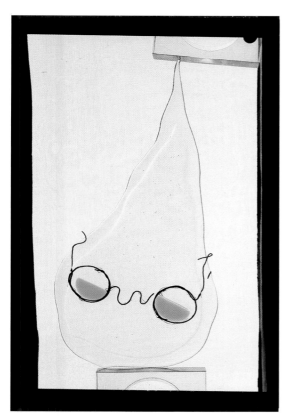

Rose Marie Parravicini,
*Lacrime su lacrime
(Tear upon tear),*
glass,
Milan 1994.

Deb Stoner,
Winter in L.A.,
fur and plastic,
USA 1992.

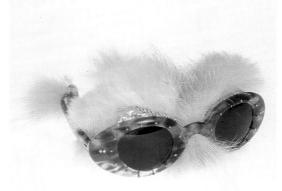

Dora Griego,
Dal punto di vista degli animali
(From the animals' point of view),
wood,
Florence 1994.

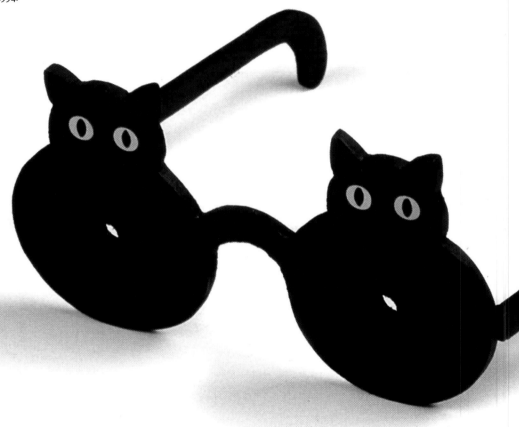

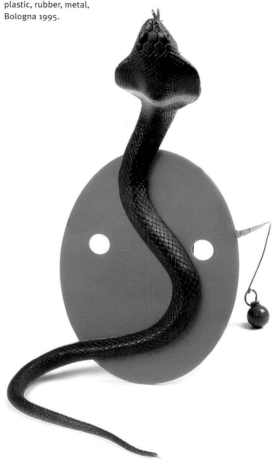

Marisa Capra,
La serpe in-setto
(Serpent on the bridge),
plastic, rubber, metal,
Bologna 1995.

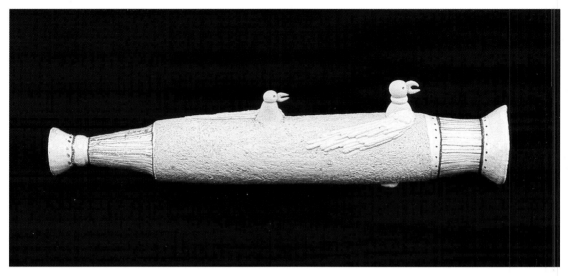

Luciano Landi,
Guardare al futuro
(Look to the future),
enamelled refractory clay,
Florence 1994.

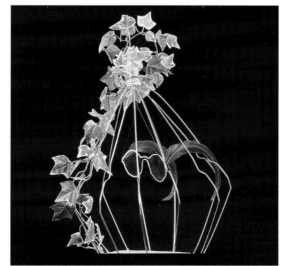

Claudia Barazzutti,
Sguardo volante
(Glance on the fly),
mixed materials,
Milan 1995.

Corrado Bonomi,
Gli occhiali piu' leggeri del mondo
(The lightest glasses in the world),
mixed materials,
Novara 1995.

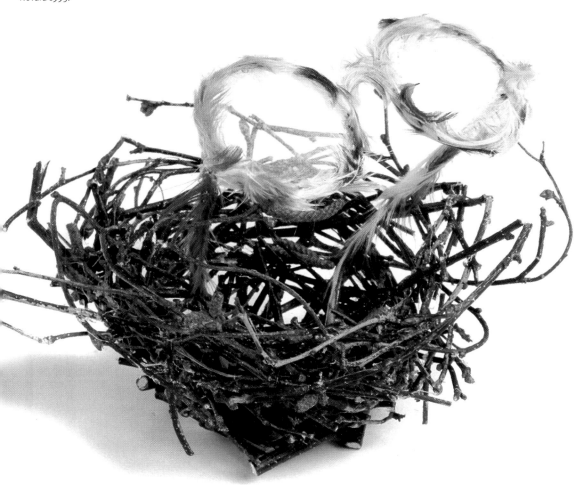

Roberto Muscinelli,
Male interiore
(Inner pain),
graphite, nails,
acrylic paint,
Milan 1994.

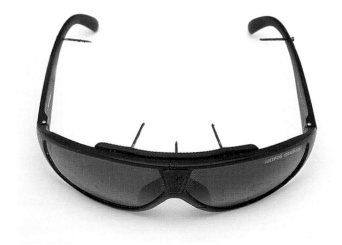

Cristina Burzio,
Hard core vision,
ceramic,
Florence 1994.

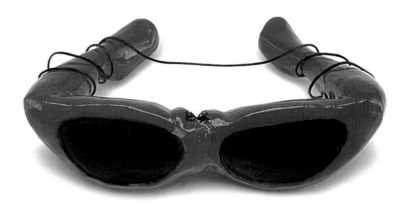

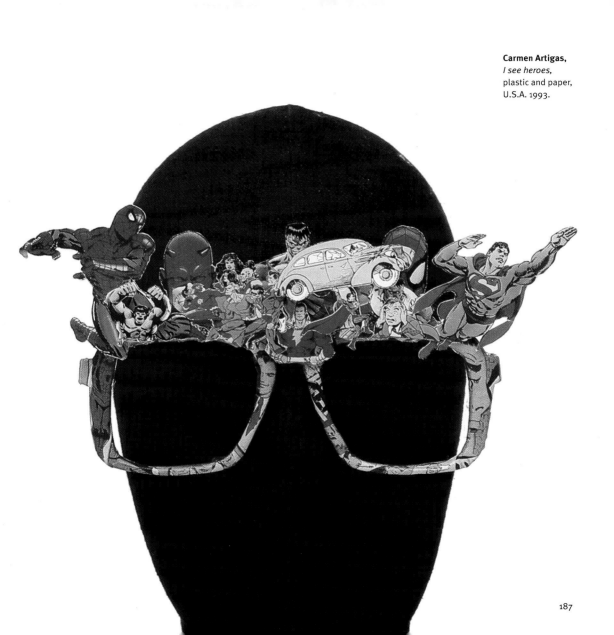

Index of Artists

Adam, Brian . 55,120,135
Aiello, Maria Agata 152
Ambery-Smith, Vicky 125,126,127
Angelosanto, Paolo 134
Antonelli, Gianluigi 83
Arcofora,Giuseppe 159
Arevalo, Antonio . 147
Armani . 10
Artigas, Carmen . 187
Avital, Solomon . 6
Barazzutti, Claudia 184
Beane, Hilary . 153
Bertan, Luca . 119
Bianchi, Maria Gloria 54
Billi, Luigi . 69
Boccardi, Pietro . 146
Bonomi, Corrado . 185
Borghi, Silvia . 150
Borrelli, Domenico 134
Borrini, Sergio . 88
Bottinelli Montadon,Carlo 133
Brenzini, Paolo . 171
Buehler, Paulyr . 47
Burzio, Cristina . 186
Busisi, Elena . 50
Busto, Andrea . 109
Cagianelli, Antonio 149
Calugi e Giannelli 111

Camillo, Marisa . 102
Ceppellotti, Federica 142
Capra, Marisa . 183
Caropreso, Manlio 77
Celentano, Michael 51
Cerrai, Ivano . 115
Chalmers, Simon . 69
Citron, Anita . 34
Clarkson, Shaun . 154
Conte, Fabio . 64
Cosua, Maurizio . 64
Cotza, Paolo . 132
Cremoni, Francesco 110
Cresti, Matteo . 118
D'Angelo, Ferruccio 65
Dattis, Antonio . 141
De Sanctis, Fabio 82
De Sanctis, Nico . 75
Della Valle, Francesca 103
Destito, Claudio . 119
Di Blasi, Viviana . 108
Di Somma e Giannotti 95
Di Somma, Giuseppe 124
Dynys, Chiara . 61
Elkaim, Charles . 154
Esposito, Irene . 107
Fallani, Roberto . 117
Favetta, Maurizio 74

Ferrari, Candida . 72
Ferré . 170
Francone, Walter . 160
Gafforio, Luca . 20
Gale, Bill . 109
Gallotti, Pierangelo . 93
Gastel, Giovanni . 45
Gaultier, Jean Paul 130
Gennai, Delio . 88
Gherardi, Gai & Barbara Mc Reynolds 169
Giannini, Adriano . 46
Giannoclaro, Marina 157
Gigli, Romeo . 128
Gonzales, Alba . 85
Grassino, Paolo . 148
Gregory, Anthony . 116
Gribaudo, Ezio . 144
Grieco, Dora . 182
Grimoldi, Angela e Giovanna 179
Hadjadj, Bruno . 101
Hesh, Linda . 155
Humeres, Paulina . 68
Iacovangelo, Mirella 166
Jakober, Ben e Yannik Vu 81
Jannini, Ernesto . 166
Jones, Jasper . 23
Kirchoff, Thorsten . 76
Kostabi, Marc . 87
Kreile, Claudia . 146
La Pietra, Ugo . 94
Lacotte, Pascal/I.D.C. 138
Lanci, Amedeo . 158
Landi, Claudia . 46
Landi, Luciano . 184
Leoncini, Monica . 47
Lo Grasso, Mercurio 96
Lo Monaco, Gaetano 89
Lodola, Marco . 178

Lombardelli, Michele 88
Lucca Taroni, Roberto 84
Lucente, Gino . 114
Lucidi Pressanti, Marco 152
Macdonald, Marcia . 162
Magnanelli, Marcello 113
Make . 140
Manfredi, Mauro . 63
Mangili, Lorenzo . 78
Mann, Thomas . 52
Mangano, Alice e Nicola Console 133
Mantovani, Gianni . 112
Marangoni, Federica 145
Massari, Luciano . 58
Mazza, Samuele 12,172
McNair, Nathan . 71
Meli, Rosy e Silvia Manna 163
Misesti, Riccardo . 34
Moroni, Oliver . 56
Mugler, Thierry . 131
Munari, Bruno . 98
Muscinelli, Roberto . 186
Nava, Nadia . 103
Nikas, Yorgo . 86
Oatman, Rachelle . 174
Ogata . 176
Öki, Izumi . 66
Osti, Massimo . 168
Padula, Maria Teresa 77
Pagnelli, Gianfranco 49
Palmizi, Mimmo . 104
Parisi, Ico . 99
Parravicini, Rose Marie 181
Passigli, Chiara . 177
Pezzatini, Lorenzo . 67
Piccione, Giuseppe . 141
Prometti, Enrico . 141
Ramotto, Pierpaolo . 74

Ricci, Giuseppe.........................161
Ricci, Oronzo90
Rizzoli, Giovanni163
Romano, Ciro...........................46
Rosenstock, Fried60
Rosin, Maria Grazia....................70
Rozkewicz, Mary Beth..................155
Ruiu..................................106
Ruzzi, Maurizio73
Saboff, Rhonda....................158,176
Salas Acosta, Andres68
Salvatore, Nicola....................62,117
Sanfilippo, Tonino137
Sanna, Arnaldo94
Sansonetti, Rosemarie164
Santacroce, Isabella105
Santiago, Glorimar48
Santiccioli, Beatrice....................102
Sapey, Teresa..........................100
Sarnin, Stéphane139,142,143,180
Scacchetti, Luca........................147
Scarabelli, Davide119

Scott, Joyce............................153
Seaver, Robert120
Shirley, Adam..........................128
Siracusa, Alfonso........................67
Spada, David156
Spinosi, Graziano.......................140
Steffian, Emily121
Stoner, Deb123,181
Tarshito (Nicola Strippoli).................97
Telarico, Giulio167
Theiss, Vernon162
Tomasini, Antonella......................79
Toscani, Oliviero e Carlo Spoldi42,44
Trevissoi, Claudia57
Tsiaras, Philip80
Vadalà, Angelo.........................106
Vigna, Giorgio129
Weiske, Ellen169
Werner, Bettina53
Wolf, Silvio165
Xerra, William.........................136
Yamamoto, Yohji175